ROYAL ACADEMY ILLUSTRATED 2003

'Rapport is the affinity between things, the common language; rapport is love, yes love. Without rapport, without this love, their is no longer any criterion of observation and thus there is no longer any work of art.'
Henri Matisse

ROYAL ACADEMY ILLUSTRATED 2003

A selection from the
235th Summer Exhibition

Edited by Frederick Cuming RA

Royal
Academy
of Arts

Contents

Sponsor's Preface

A.T. Kearney's involvement in one of the UK's most important annual art exhibitions is a great source of pride; not just for our staff, but also for our clients and partners across the globe who view it as a tangible example of our commitment to the arts.

Our sponsorship of the Summer Exhibition also goes some way to underline the other arts programmes in which we participate. These include our own initiative, 'Portraits of Business', for which each year we commission Royal Academicians to paint their impressions of leading multinational companies, thus inspiring greater dialogue between business and the arts. You will see this year's 'portrait' of HSBC by Chris Orr RA hanging in the Vestibule.

A.T. Kearney have sponsored the Summer Exhibition for the past five years, and we are delighted to have helped the Royal Academy to create a stunning art exhibition for over 100,000 people to enjoy each year.

We hope that this year's visitors will be inspired by the variety and creativity of the 235th Royal Academy Summer Exhibition.

Carl Hanson
UK Managing Director

ATKEARNEY
an EDS company

Introduction

There is nothing like it anywhere else in the world. The Royal Academy Summer Exhibition is not only the largest open show on earth, it's also the longest lived. Since 1769 there's been an exhibition every summer, even during the height of the Blitz in the Second World War. The show hasn't always been at Burlington House, though, where the Academy's been located only since 1869. Until then the annual event had taken place first at a building on Pall Mall, then at Somerset House, and then at the National Gallery in Trafalgar Square.

Though some critics like to carp that the Summer Exhibition always remains in every respect the same, this year's show – the 235th – would doubtless startle and probably also irritate visitors to the exhibition of 1903 (it might do the same to the now long-dead Academicians of a hundred years ago). Change there has been, if not often dramatic and mostly gradual. Nevertheless, what we're offered in 2003 is different in several important ways from its quite recent predecessors, even the exhibition of as little as two years ago.

Some changes are made possible by external factors, and the refurbishment of what's now known as the Annenberg Courtyard is one of them. Today, this grand public space, its statue of Reynolds, the Academy's first President, garlanded as usual for the duration of the exhibition, provides a more sympathetic setting for sculpture of every imaginable kind than ever. This year, though, there's just one work on view. Itself ten feet tall and raised up on an equally high plinth, David Mach's gigantic sculpture of a fire-eater theatrically and impressively spouts real fire at regular intervals. As if this Mach monument weren't a sufficient welcome to Burlington House, there's another inside: a large, shiny female nude made entirely from metal coat-hangers, one of Mach's characteristically resourceful transformations of the trivial into the wonderful and weird.

Mach's fire-eater may prove to be one of the lasting memories of this year's Summer Exhibition. So may Anthony Green's extraordinary *Resurrection*, the vast autobiographical hybrid (is it a sculpture, a painting, an installation?) that, together with a series of related prints, fills Gallery X. Equally memorable are the large and spectacular architectural models of skyscrapers installed by Norman Foster in the Lecture Room.

One change will strike many regular visitors from the moment they enter the first gallery. This space is devoted almost entirely to sculpture, or at least to the work of sculptors – and so is Gallery II. Fred Cuming, the Senior Hanger (and a Member since 1969), believes that placing sculpture right at the start of the show is without precedent, though he's not prepared to argue the point with the Academy's archivist. Undoubtedly new, however, is another of Fred Cuming's ideas: a gallery (Gallery VI) reserved for the work of artists at the beginning of their careers. Cuming, with one more year on Council before becoming a Senior Academician ('all the perks but none of the chores', he confides), is also responsible for a return to tradition. The Small Weston Room is once again the place where more than two hundred small paintings can be found, to the delight of those who prefer their art to be figurative and on a domestic scale.

Gallery I

The positive atmosphere of this gallery, devoted to sculpture by both Members and non-Members, is determined by colour, not least because of the presence here of works, several of them reliefs in subtly combined hues, by one of the hangers, John Wragg (one of these reliefs decorates the cover of this book). Many of the other two-dimensional pieces on the walls are also by sculptors. Bill Woodrow, another of the hangers of the sculpture gallery (the third is Ann Christopher), draws attention to the visual connections – 'entirely fortuitous', he claims – that run along the right-hand wall, from David Mach's hugely entertaining photomontages (in one of which a pleasure beach has been added to the attractions of the Palace of Westminster) to a small etching by Barry Flanagan. 'This image relates back to his sculpture of an elephant with a hare on its back in the middle of the room,' Woodrow points out, 'and that in turn leads to Mimmo Paladino's bronze of another animal, an exceptionally long-legged horse.'

From the Paladino (he's an Honorary RA) you can also see Bill Woodrow's own enormous, tall, monochrome woodcut of a giraffe on the end wall of the next gallery. Other connections are less obvious and might even be accidental. One of them is the relationship to its surroundings of Michael Craig-Martin's large screen print ...and a 'Cello. It consists of diagrammatic, outline drawings of chairs (plus the single 'cello of the title), and its assertive flatness is emphasised by its mostly three-dimensional company.

There are unexpected formal similarities between some of the elements in the Frank Stella sculpture high up on the right-hand wall beside the door and the group of reconstructed heads, by turns joky and horrific, by Eduardo Paolozzi beneath. (The Stella, by the way, must win the prize, if there were one, for the longest title in the show: *Prince Edward von Lichnowsky, Berlin, October 23, 1810 (Correspondence No. 9)*.)

Finally, in case you miss it, there's *The Old Bust Award* by David Hensel. This small putto on a shelf is engaged in some erotically gymnastic exertions that will amuse the sufficiently broad-minded (and perhaps amaze the less physically agile as well).

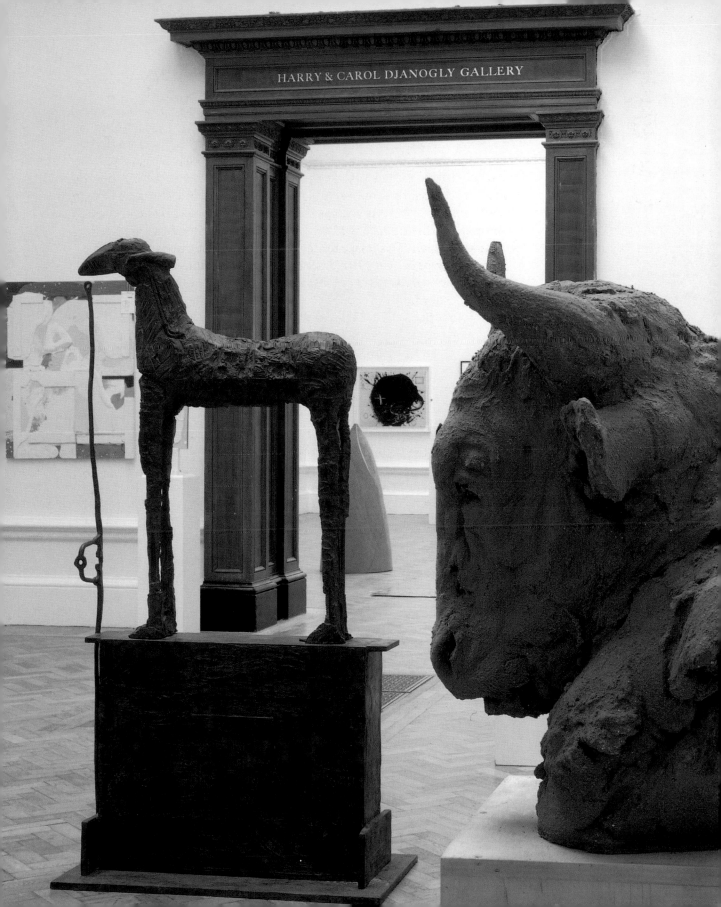

John Wragg RA
Distant Ciphers
Mixed media
H 48 cm

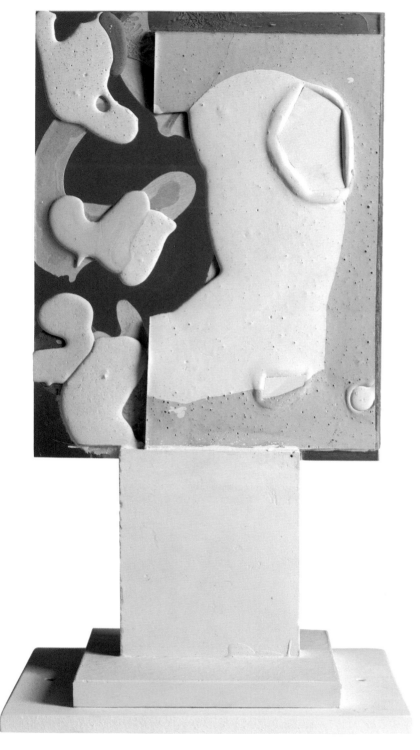

Frank Stella Hon RA
Prince Edward von Lichnowsky,
Berlin, October 23, 1810
(Correspondence No. 9)
Dia on aluminium
H 58 cm

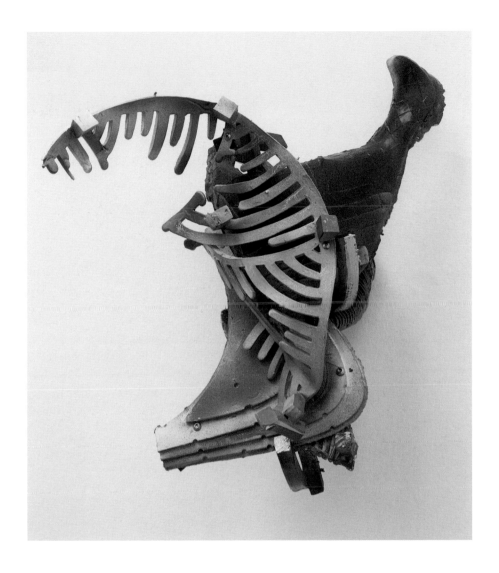

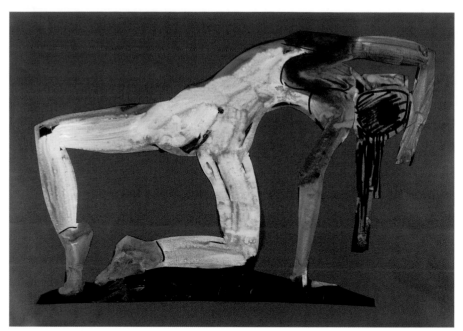

Ivor Abrahams RA
Gymnast
Mixed media
49 × 69 cm

Robert Clatworthy RA
Form
Bronze
H 30 cm

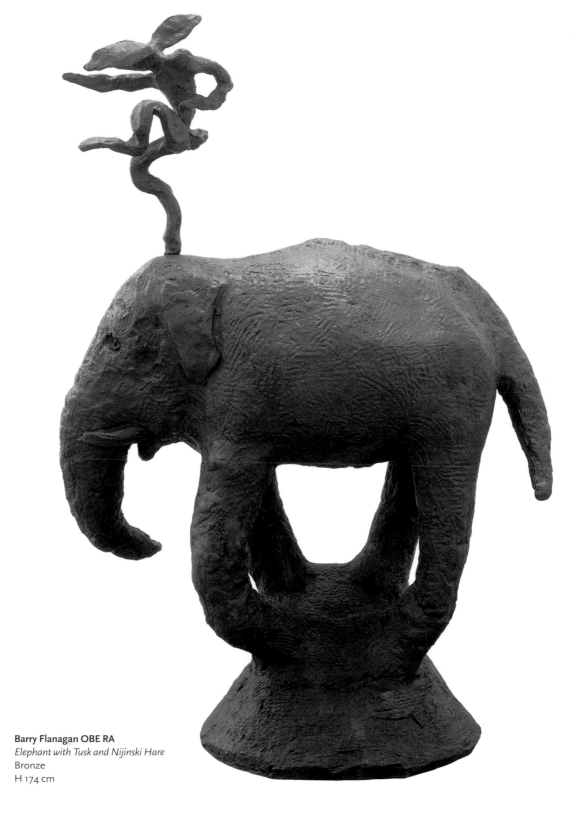

Barry Flanagan OBE RA
Elephant with Tusk and Nijinski Hare
Bronze
H 174 cm

Mimmo Paladino Hon RA
Mozart
Screenprint
35 × 44 cm

Michael Craig-Martin
... and a 'Cello
Screenprint
129 × 95 cm

Kenneth Draper RA
Pendulums of Lights
Oil and pigment
121 × 107 cm

Prof. David Mach RA
The Sword into the Ploughshear
Series 'AWOL'
Collage
18 × 22 cm

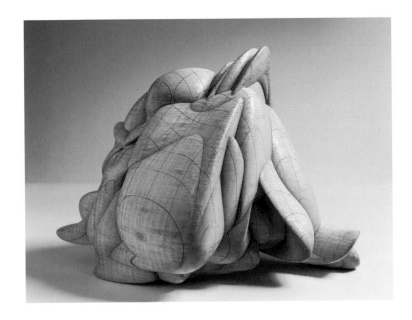

Keith Brown
Geo – 04
Paper
H 35 cm

Prof. Sir Eduardo Paolozzi CBE RA
Hermes 1994
Bronze
H 47 cm

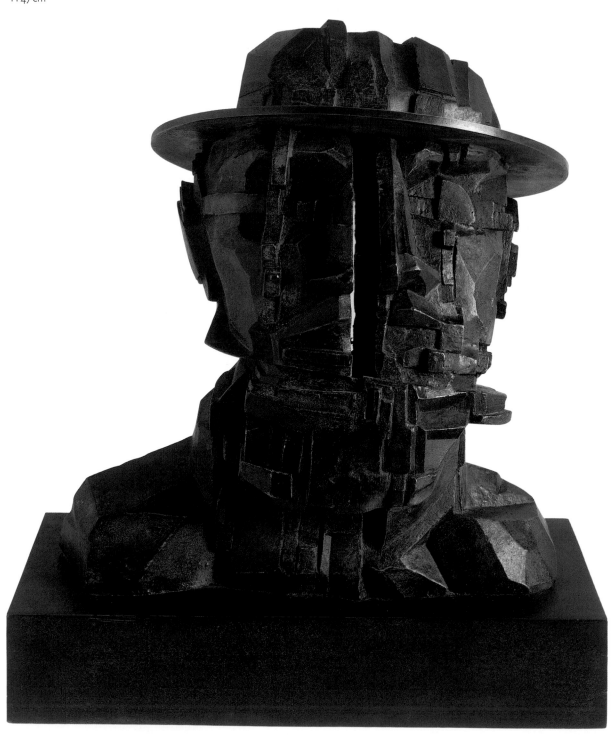

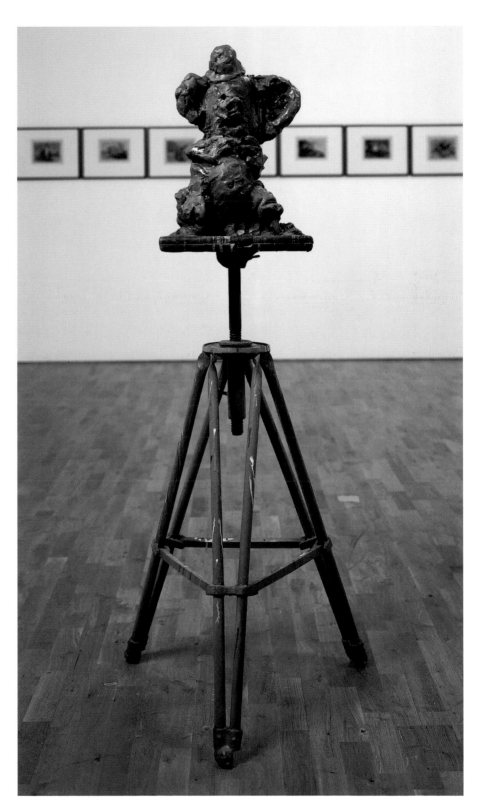

Jake and Dinos Chapman
Marriage of Reason and Squalor I
(installation at the Museum
of Modern Art, Oxford)
Painted bronze
H 158 cm

Gallery II

This gallery's the second devoted to sculpture, and its three hangers (Ann Christopher, Bill Woodrow and John Wragg) have achieved a clear visual shift from Gallery I. There colour reigns. Here the dominant note is monochrome, and the metaphorical temperature has gone down a degree or two. (Even Christopher Le Brun's bronze relief *Sense of Sight* has been painted white.)

Especially noteworthy is the group of bronzes by Lynn Chadwick (1914–2003). *Encounter VI*, one of his unmistakable, bristling figures on thin pointed legs, was made (in 1956) not long after Chadwick had established himself as one of the leaders of the post-Moore generation of sculptors, and one of the internationally best-known of those artists whose styles were, in the words of Herbert Read, shaped by 'the geometry of fear'.

As in Gallery I, Members show here with non-Members, the latter most visibly represented by some agreeably humorous pieces, like *Retro*, Cathie Pilkington's inquisitive little girl with the beehive hairdo and the wicked expression on her face. Unnerving in another way is Bill Woodrow's bronze *Missile* that mostly consists of a mountain of frog spawn with the presumably exhausted, though still coupling, frogs on top of it. Work by another hanger, Ann Christopher, includes a small abstract sculpture and four drawings that explore subtle differences of tone and texture.

Woodrow hasn't been a Member for long. Bryan Kneale, on the other hand, was elected years ago, and is a former Professor of Sculpture at the Royal Academy Schools. He's showing a group of relatively small works in bronze and other metals in this gallery together with some larger reliefs on the walls.

Figuration cohabits with abstraction here. Nigel Hall's immaculately crafted wooden *The Hour of Dusk*, based on two circles, dominates one wall by its size alone, while opposite, John Carter's *Eight Turns* looks like a relief in dark grey slate. In fact, it's in acrylic-painted plywood. Located on the floor between the two stands John Maine's *Confluence*, a large piece of pink-and-grey, regularly carved and polished granite like an artillery shell with a deep incision curving its way from base to peak.

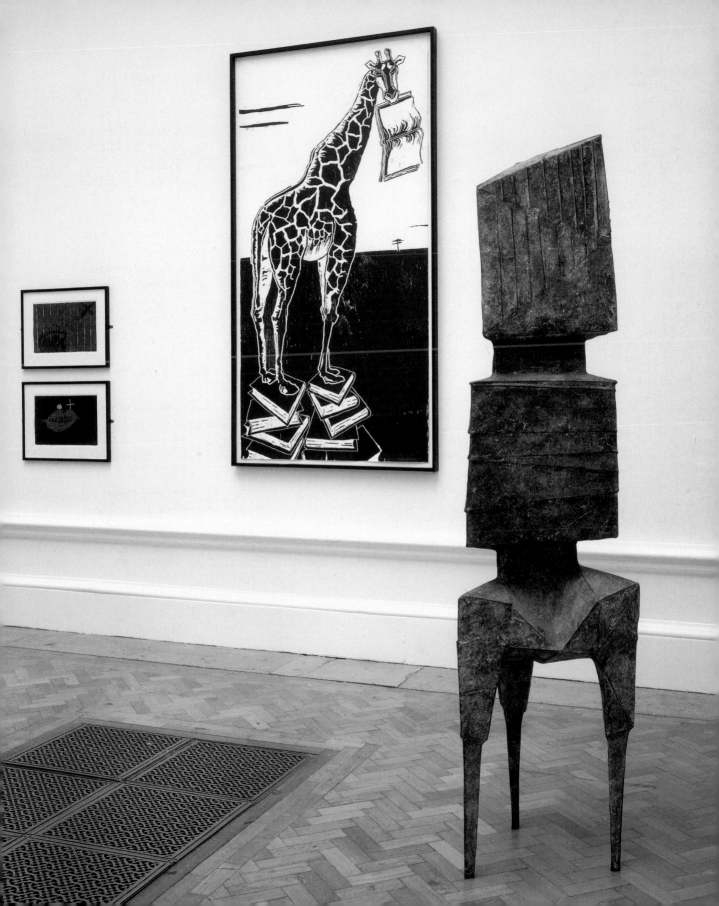

Prof. Bryan Kneale RA
Aresthusa
Mixed media
H 52 cm

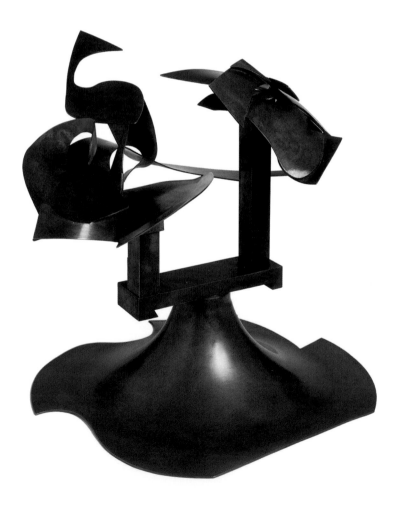

Lynn Chadwick CBE RA
Encounter VI, 1956
Bronze
H 152 cm

Ann Christopher RA
Silent Shadows 18
Mixed media
38 × 38 cm

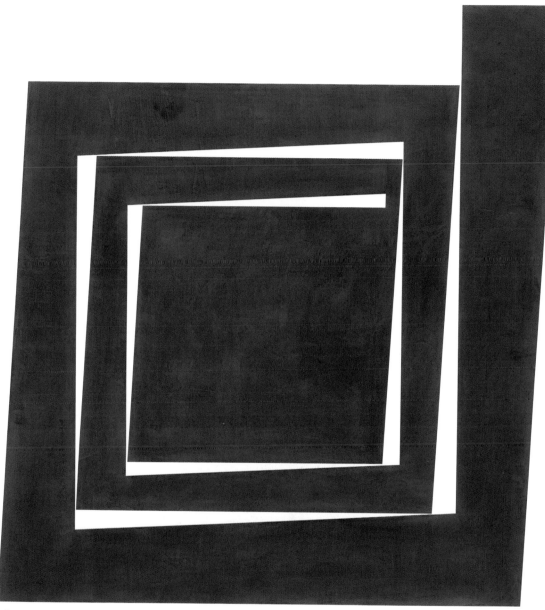

John Carter
Eight Turns 2003
Acrylic on plywood
H 124 cm

John Maine RA
Confluence
Granite
H 140 cm

Nigel Hall RA
The Hour of Dusk
Wood
H 222 cm

Alison Wilding RA
Bait
Mixed media
H 10 cm

John Cobb
Squash V
Wood
H 18 cm

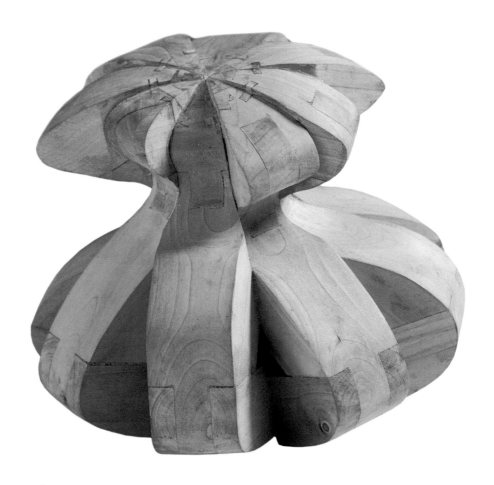

Bill Woodrow RA
Missile
Bronze
H 43 cm

William Tucker RA
Study for Sculpture (Horse) 2003
Charcoal on paper
108 × 76 cm

Antoni Tàpies Hon RA
Boca I Signes Blancs
Mixed media
32 × 49 cm

Robert Rauschenberg Hon RA
Page 10, Paragraph 3 Short Stories
Mixed media
212 × 152 cm

Large Weston Room

One of the many traditions at the Royal Academy is to elect one of the youngest Members to Council, and thus also to be one of the selectors and hangers of the Summer Exhibition. 'Doing the Summer Show for the first time often comes as such a shock', says Fred Cuming, 'that we don't expect them to do it for more than a year.' This year, Eileen Cooper was given this gallery. 'Hanging is a terribly bonding experience,' she announces. 'I'd never worked so closely with so many Members before.'

Almost all of Cooper's space is devoted to prints in every imaginable technique and on every imaginable scale (there are a few exhibits in other media, though, three drawings by Quentin Blake, best known as the illustrator of Roald Dahl's children's stories, among them). 'The breadth's the thing,' says Cooper, herself a printmaker (two of her large linocuts are in this room). 'We've got everything from tiny wood engravings to computer-generated images, and we cover everything from Pop art to landscapes, abstracts and animal pictures.' Reassuringly, many more people than dogs have put in an appearance. One of the people is Toni Martina, whose etching of his own fully frontal face is tough and rather intimidating.

There are huge woodcuts seemingly printed from carved floorboards, silk-screen prints, lithographs, aquatints and computer-generated images. There are prints from small editions and unique impressions. Among the big names are Peter Blake, Jim Dine, Allen Jones, David Hockney, Sandra Blow and Wilhelmina Barns-Graham. Mark Clark, one of the Academy's art-handlers (but in no way favoured because of his job), is showing some etchings, in which his use of the medium is as time-honoured as his subjects, not least the female nude.

There's a great deal of technical virtuosity in evidence. Colin Self's improbably large, three-sheet etching of a mechanical figure, *The Cyclopes No. 1* from his *Iliad Suite*, began life as an arrangement of found objects. Mick Moon's very big monoprint is made up of several diverse elements, two of them miniature *trompe-l'oeil* paintings of cauliflowers, all of which come together in an essentially abstract image. Technically as impressive, though in a different way, is Ian McKeever's huge carborundum etching, *After Marianne North, No. 2*.

Finally, there's a memory of last year's Summer Exhibition. One of Chris Orr's several social satires is *Eduardo and the Penguins*. It's a densely populated, almost Ensoresque description of the now sadly wheelchair-bound Eduardo Paolozzi being greeted by the President and other dinner-suited worthies during one of the Academy's many traditional opening parties.

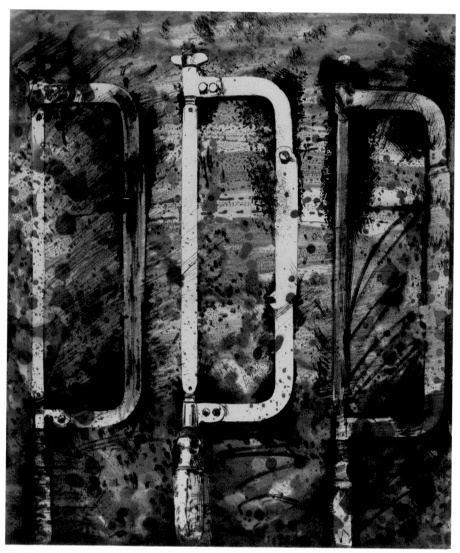

Jim Dine
Three Saws from the Rue Cler
Etching
69 × 49 cm

Ian McKeever
After Marianne North, No. 2
Mixed media
53 × 43 cm

Prof. Brendan Neiland RA
Beijing Garden
Silkscreen
76 × 53 cm

Jennifer Dickson RA
Dream Garden II (The Butchart Gardens)
Giclée
38 × 54 cm

Quentin Blake
Girl on Car Seat and Dog
Pen and ink
57 × 76 cm

Alex Ramsay
Edge of Town II
Charcoal
63 × 75 cm

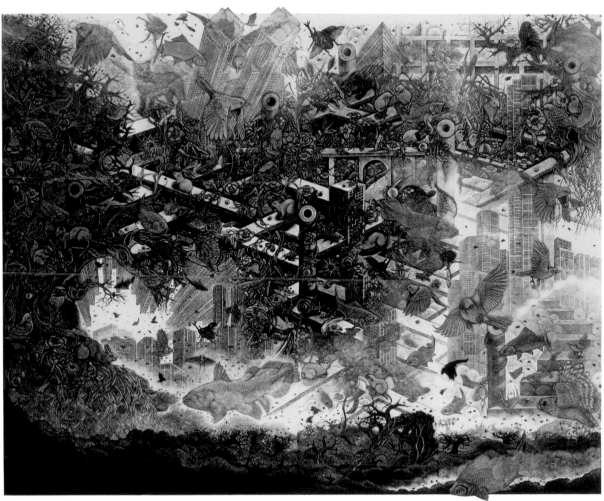

Keisei Kobayashi
Transferred Soul-Gunbu
Woodcut and etching
86 × 105 cm

Prof. Christopher Le Brun RA
Tower 2003
Etching
80 × 72 cm

Mick Moon RA
Still-life 2
Mixed media
150 × 200 cm

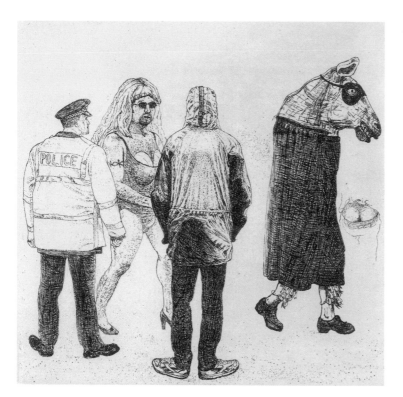

John Hewitt
Fancy Dress
Etching
20 × 20 cm

Christopher Salmon
Cat Head
Etching
19 × 20 cm

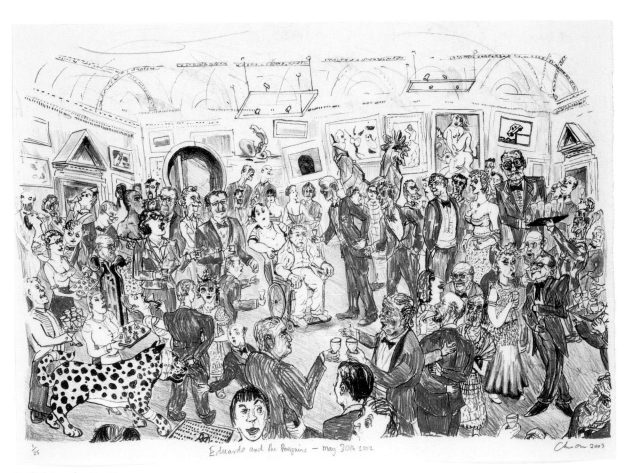

Eduardo and the Penguins – May 30th 2002

Prof. Christopher Orr RA
Eduardo and the Penguins
Lithograph
56 × 74 cm

Caroline Isgar
Vessel Veil
Etching
61 × 35 cm

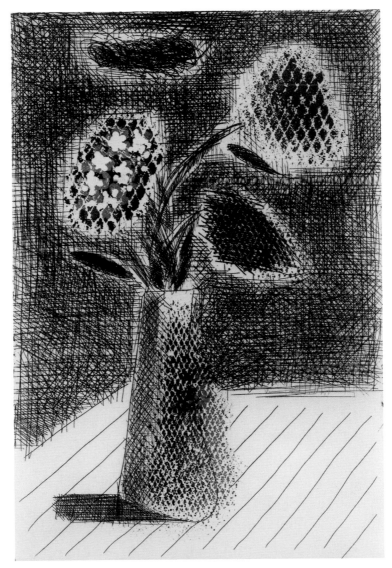

David Hockney RA
Four Flowers in a Vase
Etching
31 × 20 cm

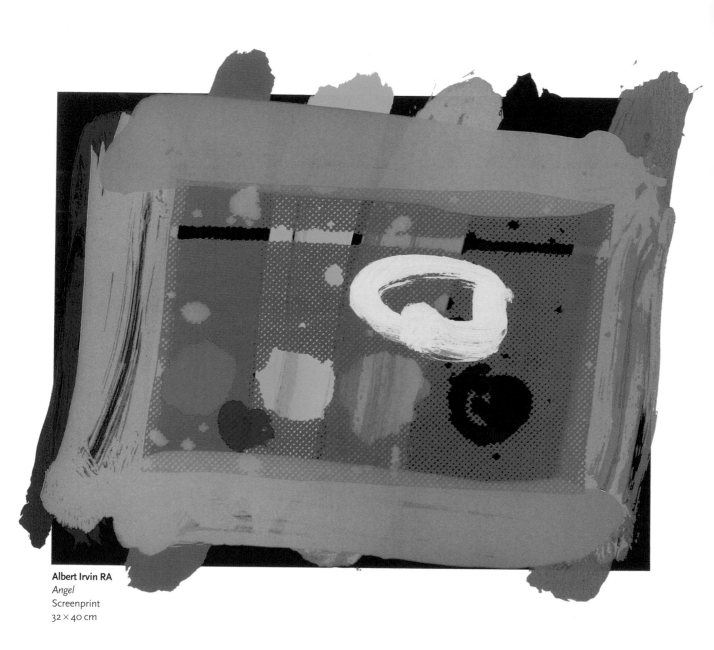

Albert Irvin RA
Angel
Screenprint
32 × 40 cm

Joe Tilson RA
Conjunction Jay Zeta
Etching and aquatint
77 × 75 cm

Emma Stibbon
Carrara III
Woodcut
127 × 125 cm

Prof. Norman Ackroyd RA
Silbury Hill, Wiltshire
Etching
16 × 32 cm

Bill Jacklin RA
Girl with Dog, Central Park I, 2001
Monoprint
25 × 20 cm

Peter Freeth RA
What the Papers Say
Aquatint
48 × 67 cm

Sonia Lawson RA
A Studio Interior
Screenprint
55 × 40 cm

Toni Martina
Self-portrait
Etching
60 × 48 cm

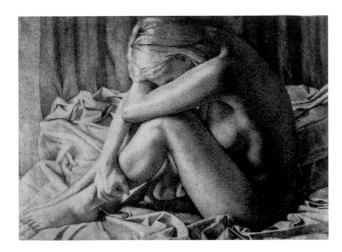

Mark Clark
Nude
Etching
28 × 39 cm

Colin Self
The Odyssey/Iliad Suite, The Cyclopes No. 1
Mixed media
217 × 104 cm

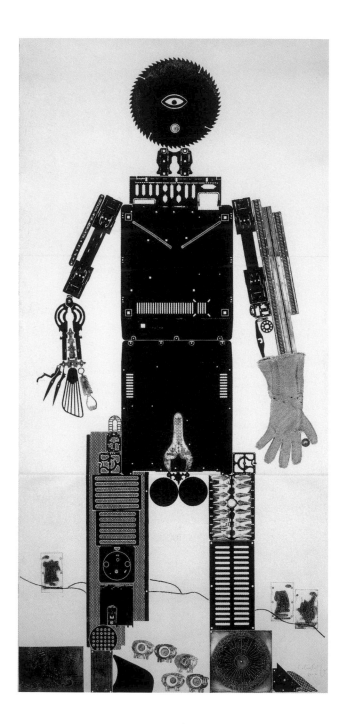

Peter Lloyd
St John's Estate II
Screenprint
151 × 99 cm

Christopher Appleby
World Stage
Mixed media
68 × 49 cm

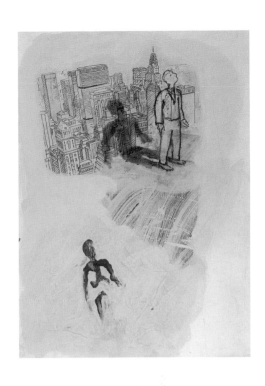

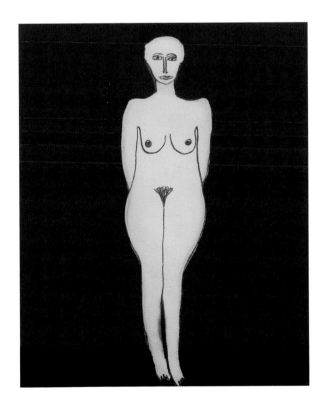

Andrezej Jackowski
Woman with Her Hair Up (Day)
Etching
75 × 60 cm

'People love this room,' Fred Cuming says, 'though many of the critics love to hate it. No one can deny, though, that if you look around closely, you'll discover some really nice bits of painting here.'

Ken Howard, who hung this distinctively intimate space, agrees. 'Size has got absolutely nothing to do with quality,' he begins. 'A small Italian landscape by Corot that's no more than eight inches high can be every bit as rewarding as a vast canvas by Monet. What's more, a painting can have a utilitarian function, and small pictures of the kind shown here are ideally suited to be hung in domestic interiors.'

Most of the work on show is confidently figurative. One exception is the work of Sally McGill whose two little abstracts are combinations of the graphic and painterly. Another exception is William Belcher's *Phantom*, an admiring nod in the direction of Ben Nicholson.

Howard talks enthusiastically about many of the some 230 paintings here, most of them by non-Members. 'There's Antony Williams's marvellous still-life. I also love Tom Fairs's *Kenwood, Path to the House*, not least because of its control of limited colour and handling that reminds me a bit of Bonnard. And there's the little *intimiste* composition, a view through a doorway of a figure undressing in a bedroom, by Bernard Dunstan.' Howard singles out a landscape by Edmund Fairfax-Lucy for special praise. 'His paintings are very poetic. He describes the sense rather than the topography of the place.' Though he's exhibited regularly for years, Fairfax-Lucy is not a Member, but Bernard Dunstan is, and so is Mick Rooney, whose compositions can look like episodes from a narrative, whose beginning and end we'll never know.

Warren Baldwin's *Wilhelmina* is a sharp-focus acrylic of the face of a model he repeatedly, almost obsessively, employs. In Jennifer McRae's tiny close-up portrait, oil is handled as delicately and transparently as watercolour. Finally, there's a self-portrait by Nadia Hebson, done with the technical precision of a fifteenth-century Flemish painting. Not everyone will notice the single tear precariously lodged in the corner of one eye.

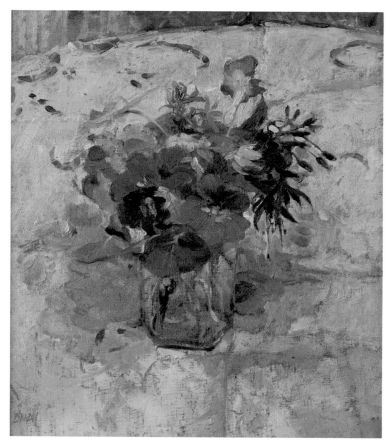

Diana Armfield RA
Nasturtiums on the Venice Tablecloth
Oil
29 × 26 cm

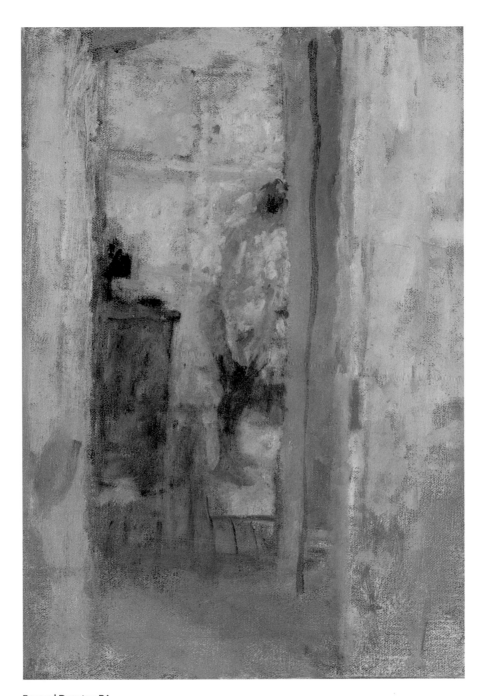

Bernard Dunstan RA
Door into Bedroom
Oil
33 × 23 cm

Jennifer McRae
Fragment
Oil
15 × 15 cm

Nadia Hebson
Untitled
Oil
32 × 23 cm

Warren Baldwin
Wilhelmina
Acrylic
36 × 24 cm

Christine Karpinski
On the Beara
Oil
39 × 29 cm

Fred Dubery
Pleasurable Neglect
Oil
44 × 90 cm

William Belcher
Phantom
Mixed media
20 × 13 cm

James Lloyd
Aurore's Footmarks
Oil
79 × 53 cm

Sally McGill
Balanced Fields
Oil
30 × 30 cm

Kristine Powley
Porthleven
Oil
30 × 26 cm

Susan Caines
Recollections
Oil
36 × 59 cm

Cedric Horner
Winter Woods II
Oil
50 × 75 cm

Mick Rooney RA
The Children in the Snow
Oil
32 × 21 cm

Henry Kondracki
Trudging through the Snow
Oil
39 × 52 cm

Lorna Vahey
Station by the Sea
Oil
19 × 29 cm

John Morley
Snowdrops in a Glass
Oil
32 × 26 cm

Edmund Fairfax-Lucy
Late Winter Afternoon
Mixed media
62 × 74 cm

Antony Williams
Paper Bag and Prickly Pear
Egg tempera
26 × 37 cm

Tom Fairs
Kenwood, Path to the House
Oil
73 × 51 cm

Gallery III

Large, boldly conceived works are usually shown to best advantage in this spacious and imposing gallery, surely one of the grandest exhibition spaces anywhere. Yet inevitably the size of the space always confronts the hangers – this year Mick Moon and Gus Cummins – with special problems. How can you give visual unity to so many paintings of such differing formats? How do you create visual connections across such an intimidating expanse of wall?

But if there are problems with such a formidable space there are also advantages. It's difficult to imagine Gillian Ayres's exhilarating compositions, all expressive impasto and boiled-sweet colours, looking as good anywhere else, and John Bellany's paintings in hot hues are shown to great advantage here, too. This is as true of his large-scale, enigmatic personal allegories as of his smaller and equally vigorous still-lifes. Both these painters are perennial favourites at the Summer Exhibition. So, too, is Adrian Berg, who's showing a group of his signature park landscapes, combinations of the directly observed and the strikingly stylised in both colour and mark.

All the artists represented in this room are Members, and all are consequently well-known to regular visitors. (The number of RAs is limited to 80, by the way, though that figure doesn't include the Senior Academicians – those over 75 – or the Honorary RAs, distinguished foreign artists who join by invitation.) Eileen Cooper has a group of deceptively simple figure compositions which, like *Lifeclass*, add symbolic implications to the seemingly everyday. Peter Blake, in a striking conflation of the old and new, situates his grave Madonna and Child beside a window with a view not of some medieval Flemish town but a very contemporary Trafalgar Square as seen from inside the National Gallery. Stephen Farthing's strange Surrealist landscape could easily serve as the cover of a science-fiction novel. And Sandra Blow is showing some of her perfectly judged arrangements of almost geometric shapes in a few saturated colours.

Some of the titles and some of the imagery here can seem inexplicable at first. Gus Cummins's triptych of dynamically arranged, mostly abstract devices (some of them collaged elements) is called *Home Front* because, he says, 'I'm always listening to the radio while I work, and if a phrase or word strikes me, I write it down. I found "Home Front" scribbled on my easel, and it came in handy at just the right time.'

The Academy is honoured to dedicate the end wall of Gallery III to a memorial display of paintings by the Chilean Surrealist painter Matta (Roberto Matta Echaurren, 1911–2003). An Honorary RA, Matta displayed work regularly at the Academy in recent years. Discussing *Italia Matta*, Gus Cummins says, 'With its wild energy, colour and scale the work is an irresistible force which stopped me in my tracks! A humbling experience.'

When planning the exhibition Council wanted Matta's imposing works to fill the end wall of Gallery III, looking down the length of the gallery towards the Chillida memorial in the Wohl Central Hall and Norman Foster's 'Sky High' architecture display.

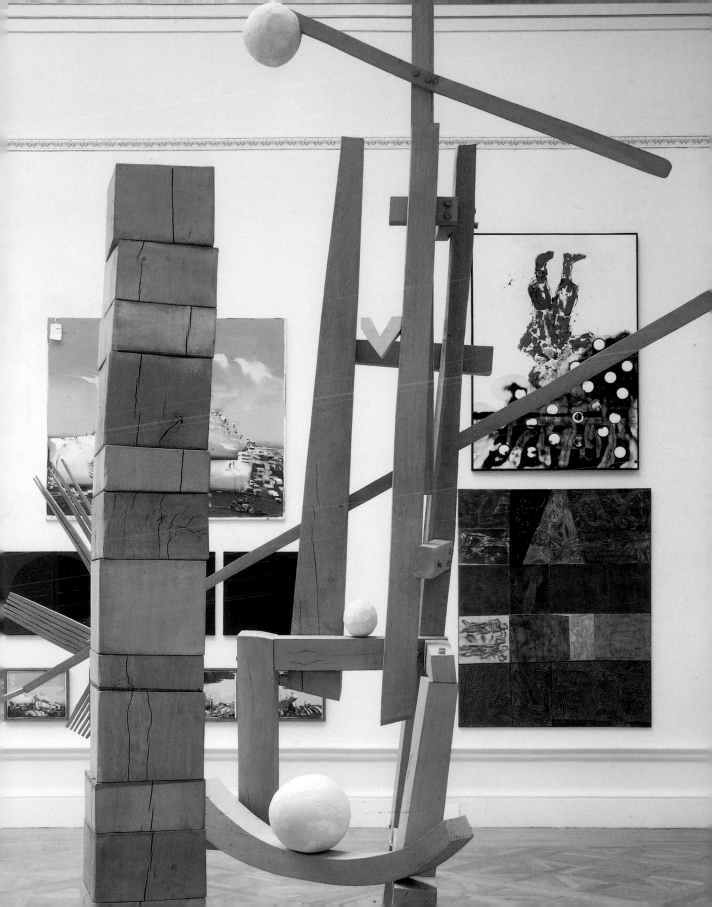

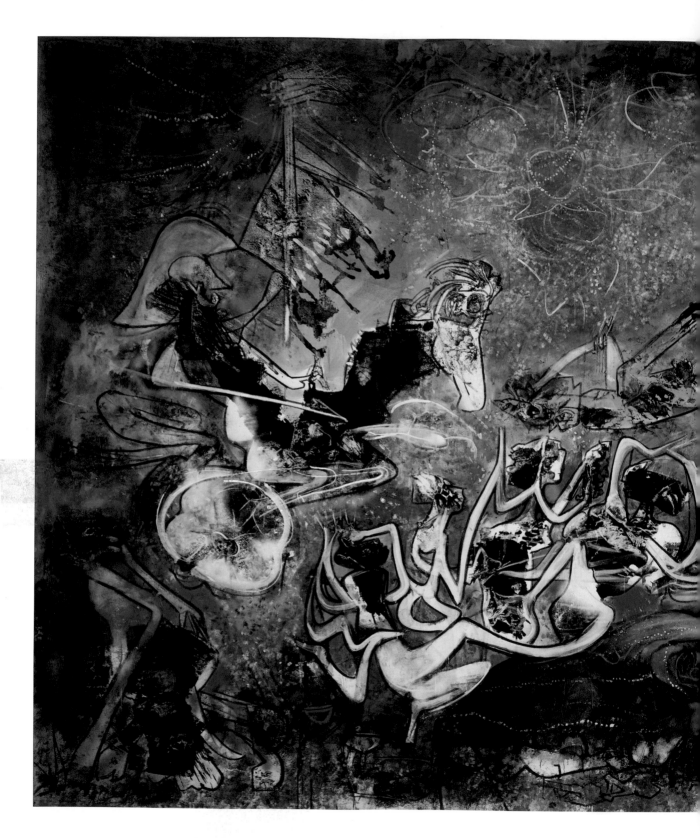

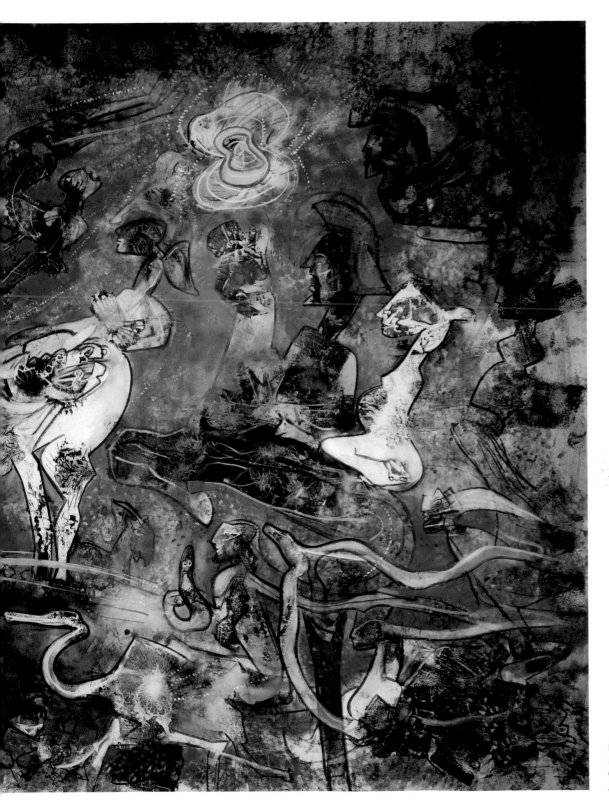

Matta Hon RA
Italia Matta
Oil
400 × 700 cm

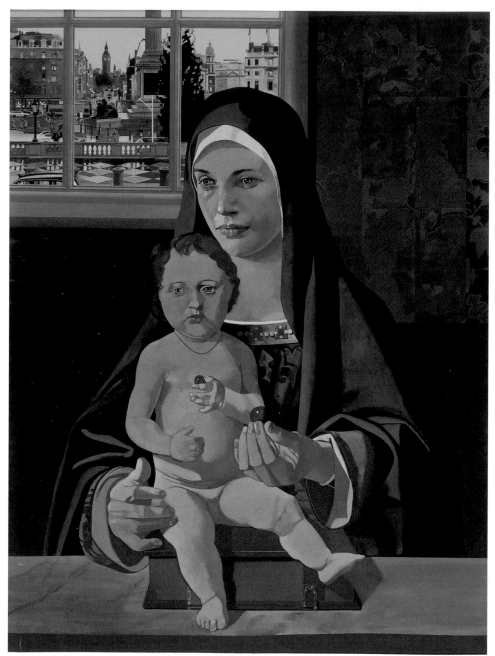

Prof. Sir Peter Blake CBE RA
National Gallery Madonna
Oil
120 × 90 cm

R. B. Kitaj RA
Erotica Judaica (Laura)
Charcoal and pastel
77 × 55 cm

Frederick Gore CBE RA
Summertime Jazz
Oil
127 × 95 cm

Sandra Blow RA
Over the Traces
Acrylic
197 × 197 cm

Gillian Ayres RA
Summerland
Oil
183 × 411 cm

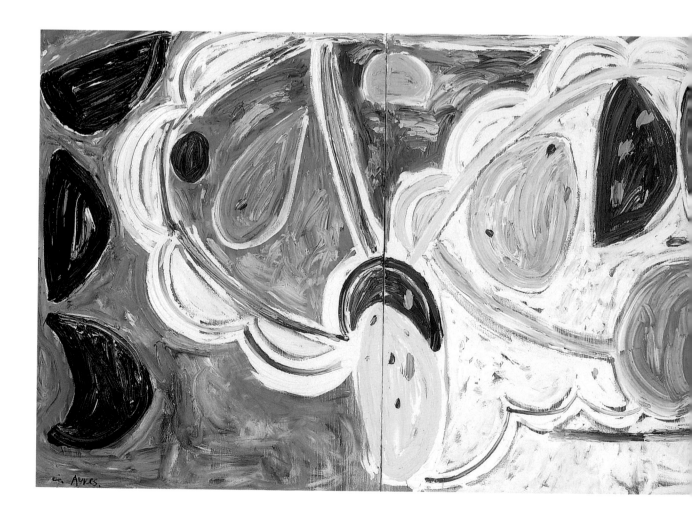

Maurice Cockrill RA
Bridge No. 3
Mixed media
43 × 46 cm

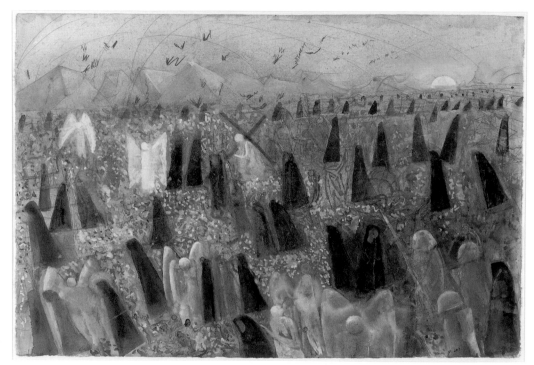

Prof. Norman Adams RA
Ghosts
Watercolour and gouache
69 × 103 cm

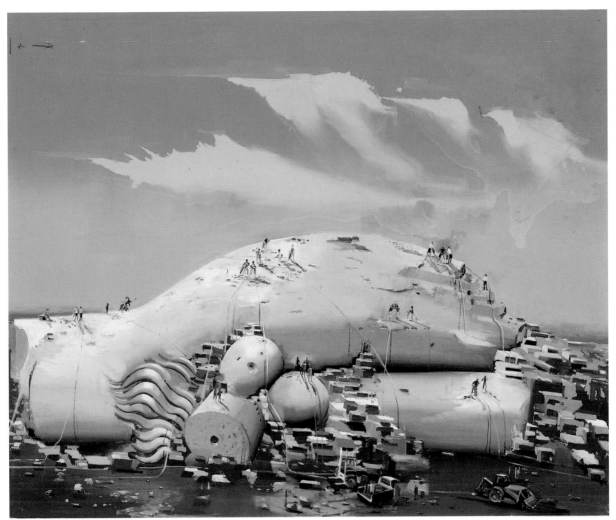

Stephen Farthing RA
Poor Foundations Were to Blame
Oil
175 × 203 cm

Anthony Whishaw RA
H211 FKE – Reconditioned 2001/3
Acrylic
121 × 305 cm

Patrick Procktor RA
Darren Prone
Oil
39 × 29 cm

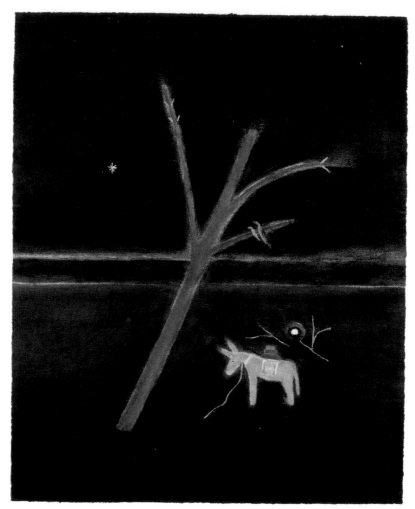

Craigie Aitchison CBE RA
Donkey
Screenprint
76 × 61 cm

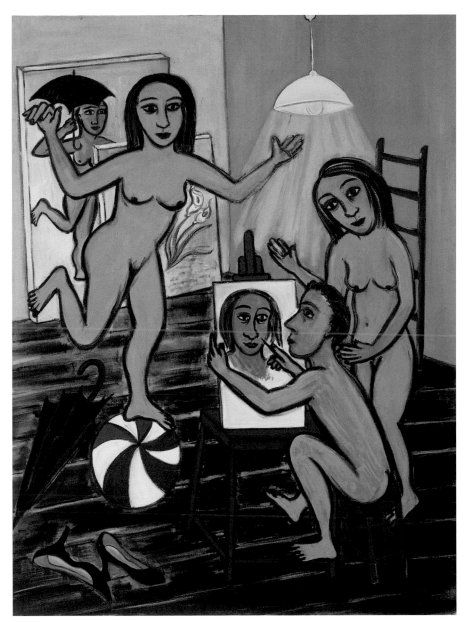

Eileen Cooper RA
Lifeclass
Oil
120 × 92 cm

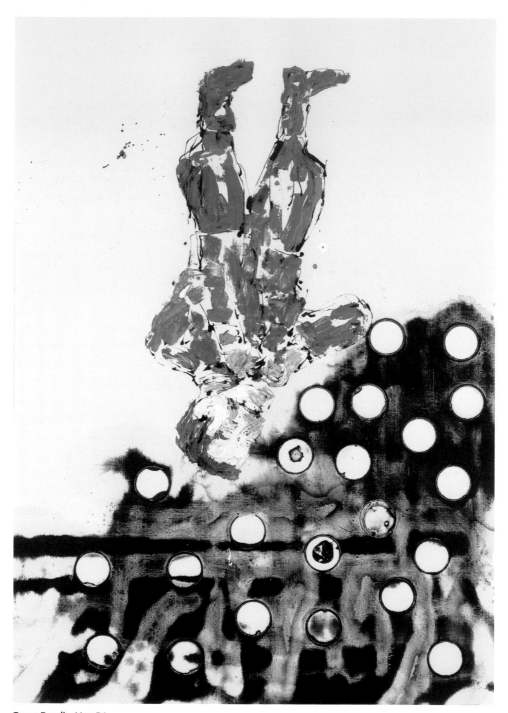

Georg Baselitz Hon RA
Juri
Oil
200 × 140 cm

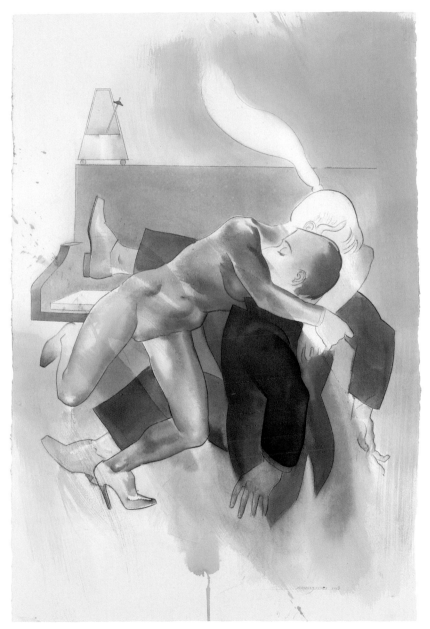

Allen Jones RA
Embrace
Watercolour
167 × 117 cm

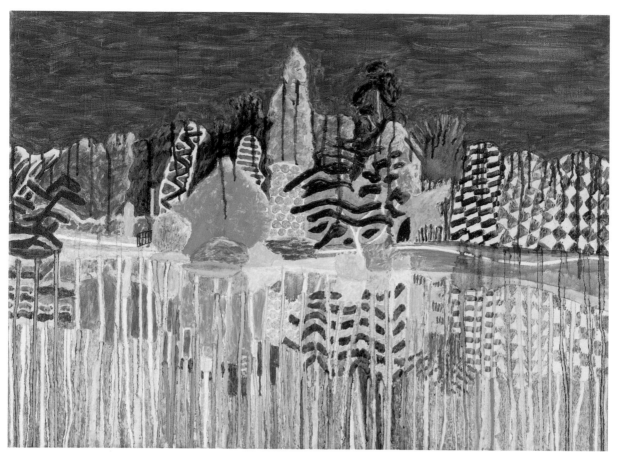

Adrian Berg RA
2nd Lake, Sheffield Park Garden,
Sussex Weald, 22 & 23 August 2001
Oil
56 × 71 cm

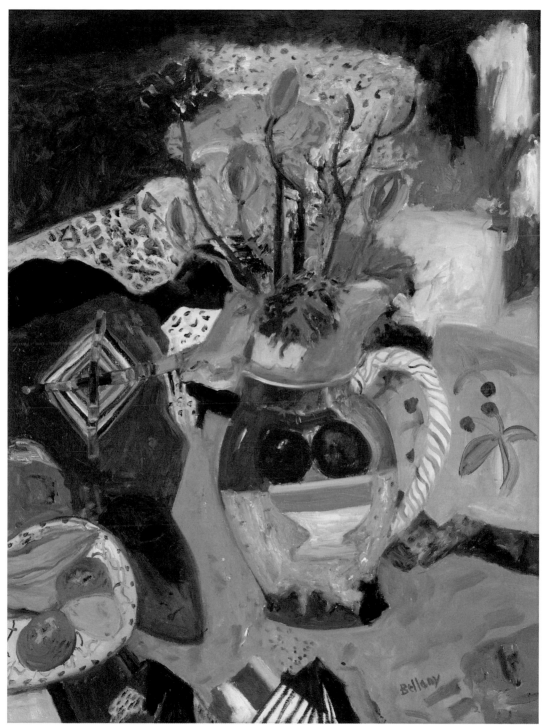

John Bellany CBE RA
Red Flowers
Oil
121 × 91 cm

Prof. Paul Huxley RA
Print Collage, Violet and Red
Screenprint
82 × 77 cm

Flavia Irwin RA
Hidden Depths 4
Acrylic
92 × 72 cm

Tom Phillips CBE RA
Ornament I
Oil
76 × 101 cm

Gus Cummins RA
Home Front
Acrylic
170 × 237 cm

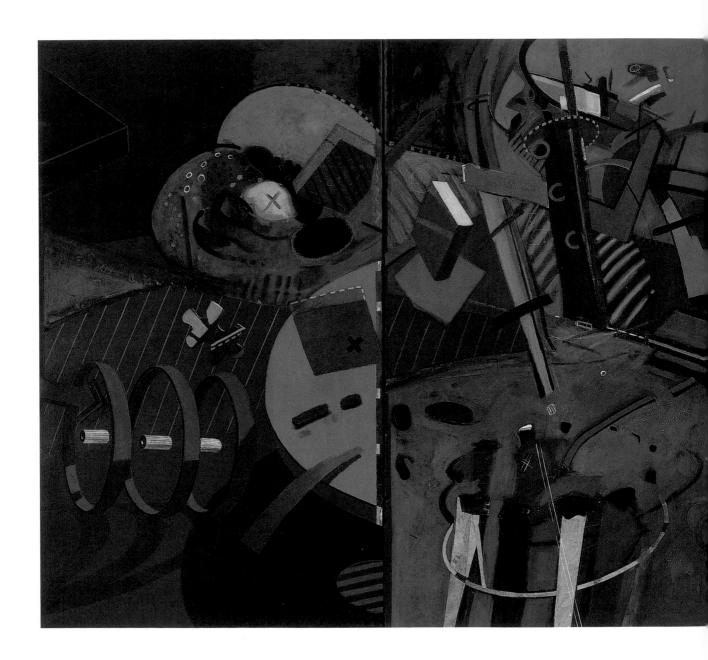

John Craxton RA
Cretan Cats
Acrylic
55 × 45 cm

Gallery IV

Hung by John Hoyland (Professor of Painting at the Academy Schools as well as an RA), this gallery contains paintings and sculptures by Members, including two smoulderingly expressive compositions by Hoyland himself. The hang seems strikingly open here, though Hoyland says he would have preferred it 'sparser still'. Doubtless some of the other hangers, all of them confronted by a shortage of space, view with envy the conditions under which Hoyland insisted he work. He fought hard for them, in order 'to preserve', in Fred Cuming's words, 'the airiness of the room, and to resist the mounting pressure on him to take works from other galleries'.

Cuming is referring to the practice, a daily occurrence during the two weeks of hanging, of shifting pieces between galleries, sometimes without the permission of the receiving hanger. Hoyland resisted all attempts to remove Anthony Caro's *Susannah and the Elders*, a sculpture in terracotta, wood and steel, from his gallery. (Caro was a student at the Academy Schools, but he's not a Member so strictly speaking Hoyland shouldn't have chosen to have him here, but, as he says with a grin, 'I wanted a touch of class'.)

Thanks to the relatively generous hang, everything here makes an impression. There's the group of paintings by Jeffrey Camp, all of them hung so close that they look like a single work, each part of which depicts an event or a landscape inspired, as so often in Camp's work, by Beachy Head. There's the group of bold and joyful abstracts by Terry Frost. There's Allen Jones's triptych, in which pianists are coupled with seductive females (one of Jones's small, formally intriguing bronzes is in this gallery, too). There's a characteristically subtle painting by Anthony Whishaw ('voluptuously arid, like Spain', in Hoyland's words), two assertive compositions by Maurice Cockrill, two paintings by Barbara Rae that look like transformations of Mexican landscapes, and some colouristically and gesturally rich paintings by Peter Coker that seem abstract at first but suddenly crystallise into nocturnal, bird's-eye views of Parisian streets. There are also two of Brendan Neiland's signature pictures of reflections in glass curtain walls. And there's a low-slung floor sculpture by the President, Phillip King, a poised arrangement of disparate elements including feathers, raw pigment, and thin, flat pebbles.

Finally, there are two commanding abstracts by Hoyland himself, the darker of the two prompted by the death this year of one of his friends, the curator and critic Bryan Robertson. It's a measure of how much the Academy has changed that Hoyland, when a student at the Academy Schools in 1960, was advised not to exhibit abstract paintings in his final show. If he did, his tutor assured him, he'd fail.

Jeffery Camp RA
Brighton Banana
Oil
65 × 40 cm

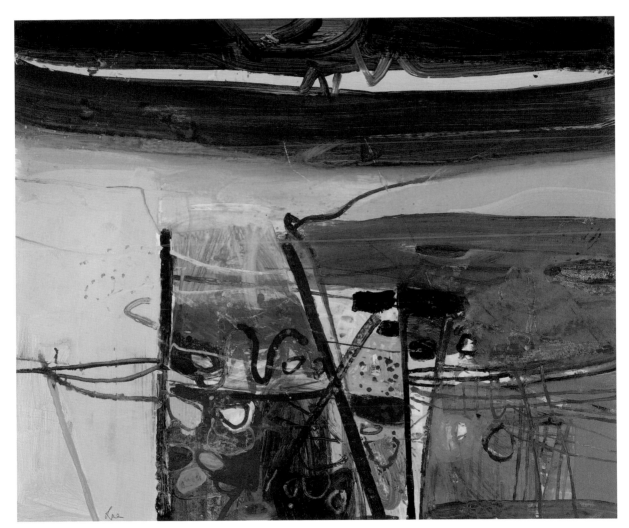

Barbara Rae CBE RA
Western Boundary
Mixed media
99 × 118 cm

Prof. Phillip King CBE PRA
Spring Place
Mixed media
H 30 cm

Prof. John Hoyland RA
Master Weaver 2.11.02
Acrylic
237 × 254 cm

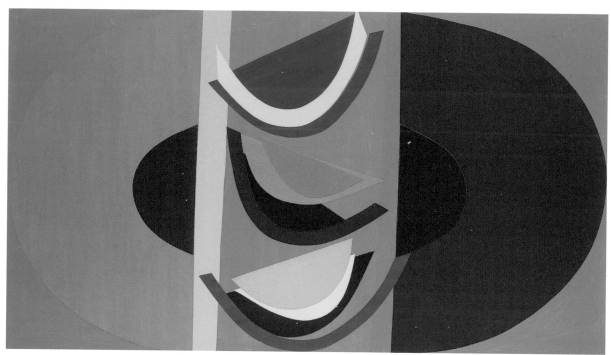

Sir Terry Frost RA
C me if you can
Acrylic
120 × 207 cm

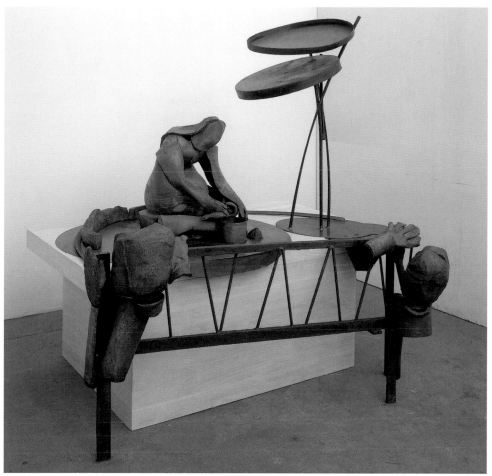

Sir Anthony Caro OM CBE
Susannah and the Elders
Terracotta, wood and steel
H 182 cm

Gallery V

Fred Cuming hung this gallery with Ken Howard. Both repeatedly felt under pressure. 'We had to accommodate harmoniously a huge number of works, most of them by Members together with a few by non-Members,' Cuming says, 'and it was difficult to find ways of bringing so many disparate styles together. Philip Sutton, for example, has a group of paintings here, and his colour is totally unlike anyone else's. Elizabeth Blackadder, whose colours are far more delicate and restrained, is here too.' Blackadder's best known for her watercolours, and so is Leslie Worth, who's showing a large Turneresque landscape. Watercolours are usually under-represented in the Summer Exhibition, but perhaps a new prize, awarded for the first time this year and donated by Winsor & Newton, will do something to redress the balance.

Somehow the hangers managed to find room for some 115 paintings, a figure that pleases them both. 'Such close hangs aren't to everyone's taste,' Cuming concedes, 'but I'd rather see more work than less, and more artists with a chance to show what they can do.' He adds that 'Council does have the power to veto me and' – this with a smile – 'that fact did indeed restrain my urge to fill up every last space'.

Cuming's represented in this gallery himself. One of his landscapes, *Ferry to Polrwen*, evokes the atmosphere of a summer evening at dusk, just when the lights are going on, in this Cornish beauty spot near Fowey. Ken Howard's here, too, with a view of Venice, and a self-portrait done in his studio there. It's a very good likeness, and this may have something to do with his method. The straight red lines you can see in the painting were copied from marks painted as a guide on the mirror he used.

Other long-standing Members are represented here, too. One is Kyffin Williams, whose *Waterfall, Nantffrancon*, is a landscape entirely in black, white and grey, the heavily impastoed paint laid on so as to suggest the physicality as well as the look of the rocks and stones. This is an exceptionally strong picture: high on the wall, it nevertheless holds its own. Other Members in this gallery include Donald Hamilton Fraser, Mary Fedden and Olwyn Bowey, whose dying sunflowers strike an elegiac note. Examples of Leonard McComb's inimitable, closely worked style include his pastel *Portrait of Rebecca*, with its animated surface of translucent colours. Anthony Eyton's lively pastel provides a touch of déjà vu. It's a typically vigorous view of the Annenberg Courtyard at the time of last year's Summer Exhibition.

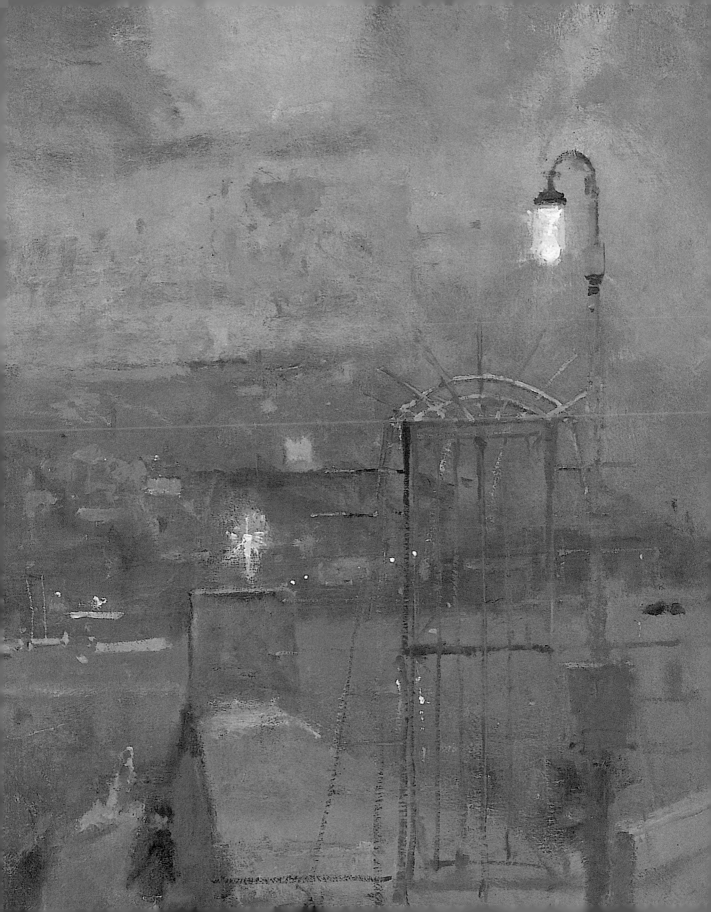

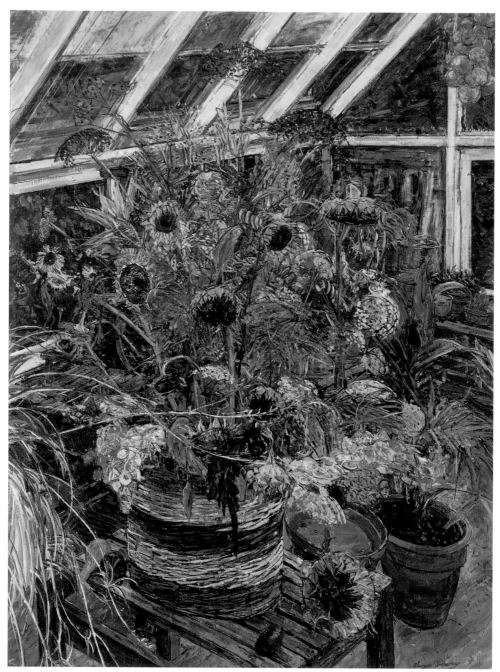

Olwyn Bowey RA
After Midsummer
Oil
107 × 78 cm

Frederick Cuming RA
Ferry to Polrwen
Oil
89 × 89 cm

Tom Coates
February Visitors
Oil
162 × 72 cm

Karn Holly
Table
Oil
89 × 110 cm

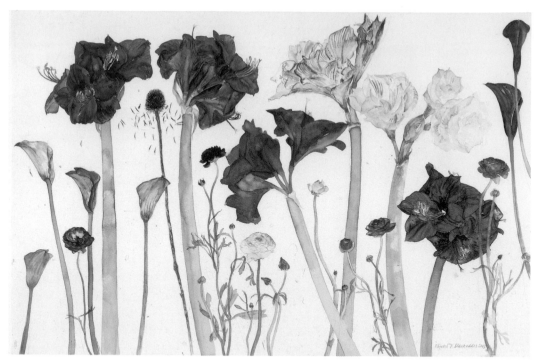

Elizabeth Blackadder OBE RA
Amaryllis, Ranunculus and Other Flowers
Watercolour
69 × 106 cm

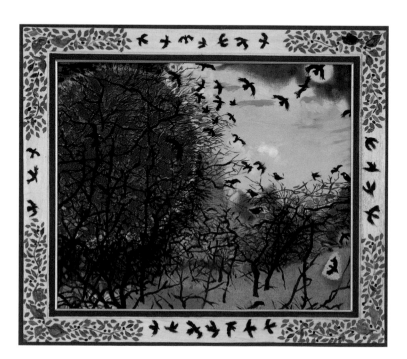

Philip Sutton RA
Who would have thought it!
Oil
81 × 92 cm

Sir Kyffin Williams OBE RA
Waterfall, Nantffrancon
Oil
126 × 74 cm

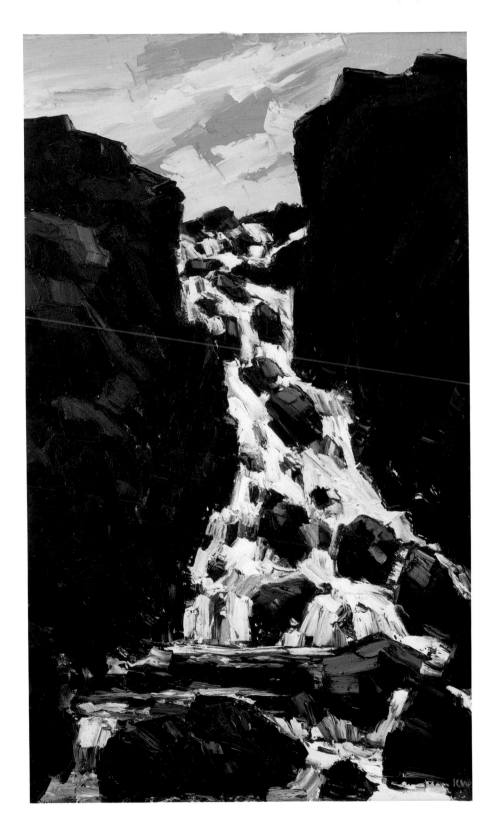

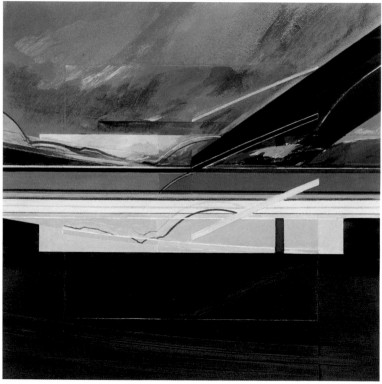

Brian Plummer
November, North Ribblesdale
Mixed media
45 × 45 cm

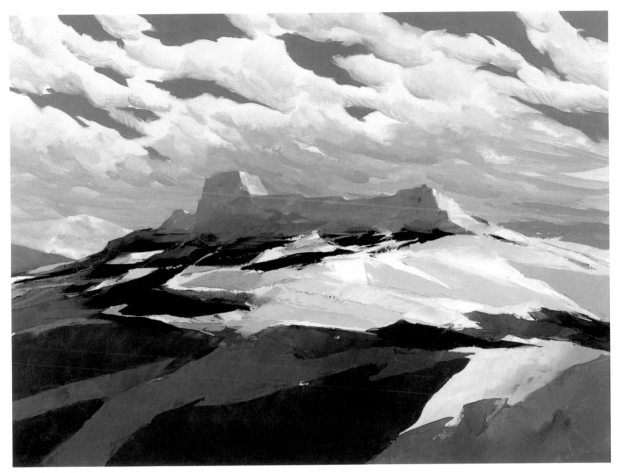

Donald Hamilton Fraser RA
Montsegur
Oil
75 × 100 cm

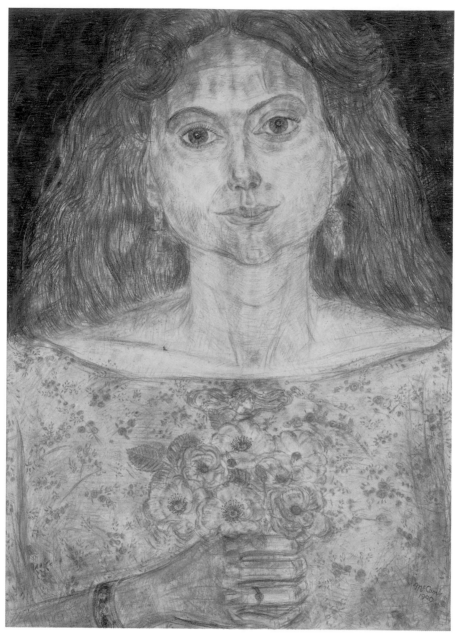

Leonard McComb RA
Portrait of Rebecca
Pastel
127 × 91 cm

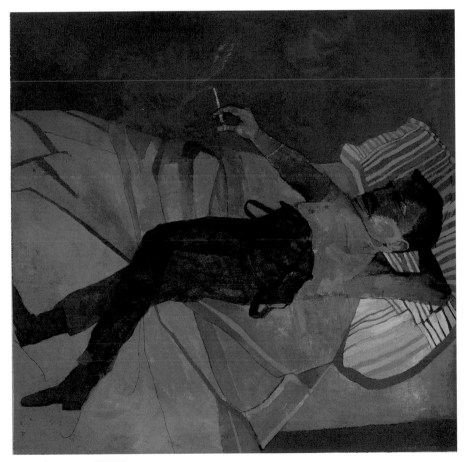

Leonard Rosoman OBE RA
Man Lying on a Bed – Maximilian Schell
in John Osborne's 'A Patriot for Me'
Acrylic
90 × 90 cm

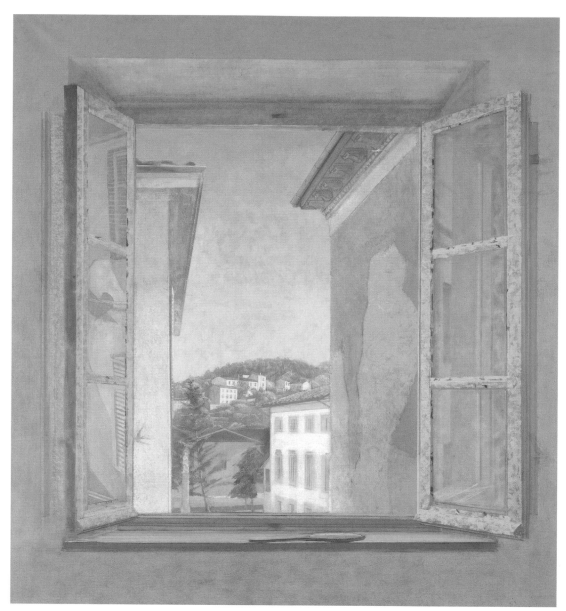

David Tindle RA
Sabrina's Room
Egg tempera
107 × 99 cm

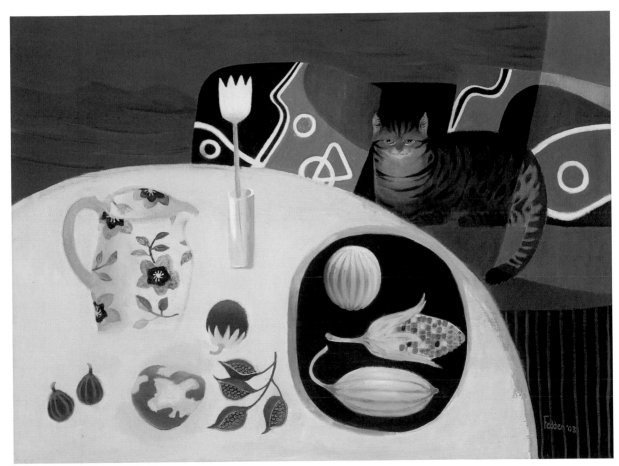

Mary Fedden OBE RA
Pussy on the Sofa
Oil
89 × 119 cm

Ken Howard RA
Self-portrait in Venice
Oil
120 × 58 cm

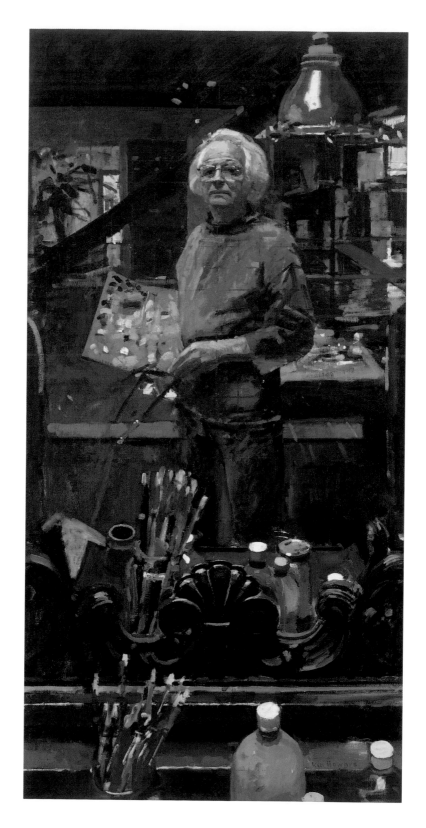

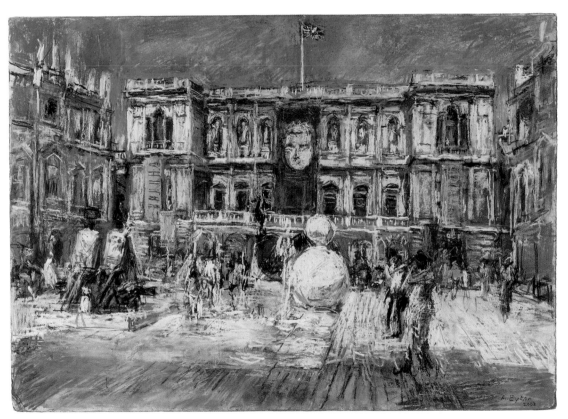

Anthony Eyton RA
The Annenberg Courtyard
Pastel
55 × 76 cm

Ben Levene RA
Rain on the Hills
Oil
46 × 47 cm

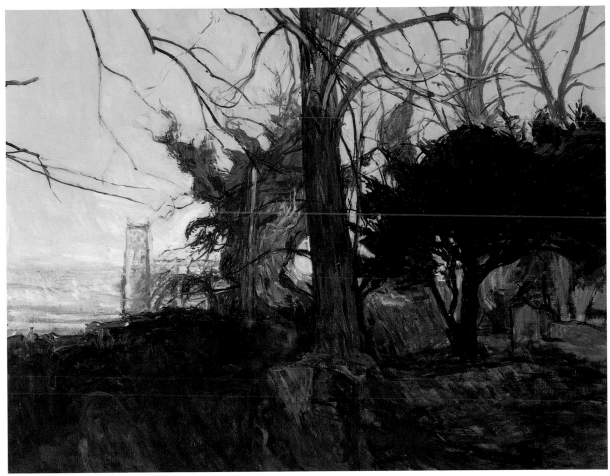

William Bowyer RA
Church on the Marshes
Oil
70 × 91 cm

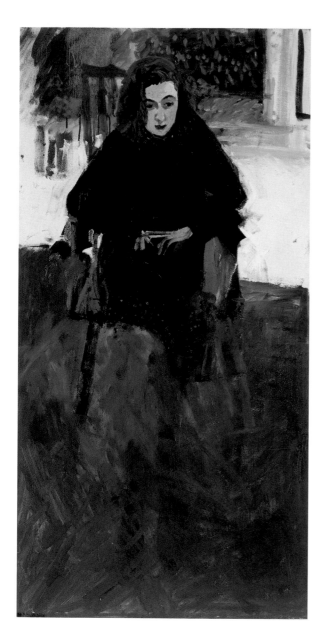

Jean Cooke RA
Wendy in the Studio I
Oil
122 × 61 cm

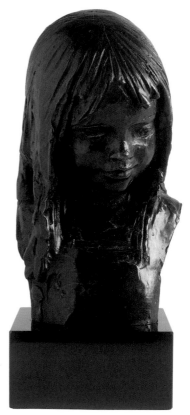

James Butler RA
Child
Bronze
H 26 cm

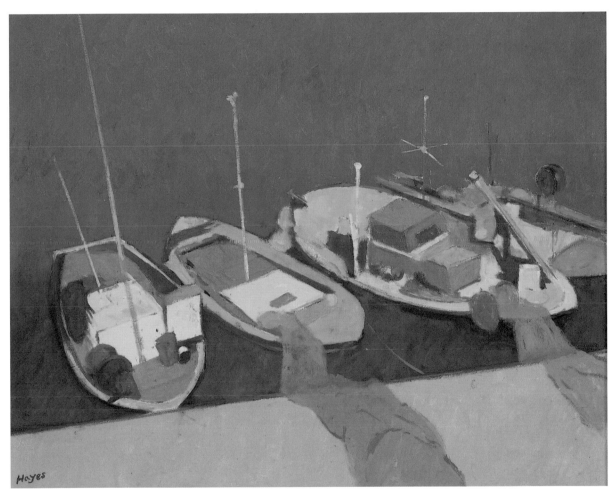

Colin Hayes RA
Cretan Fishing Boats
Oil
59 × 75 cm

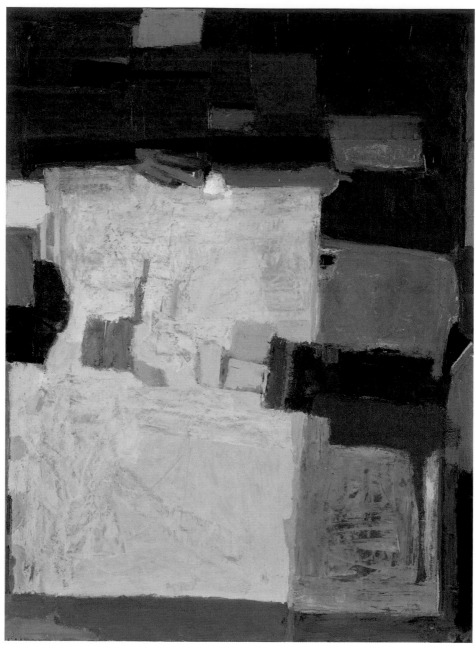

Arthur Neal
Studio
Oil
122 × 92 cm

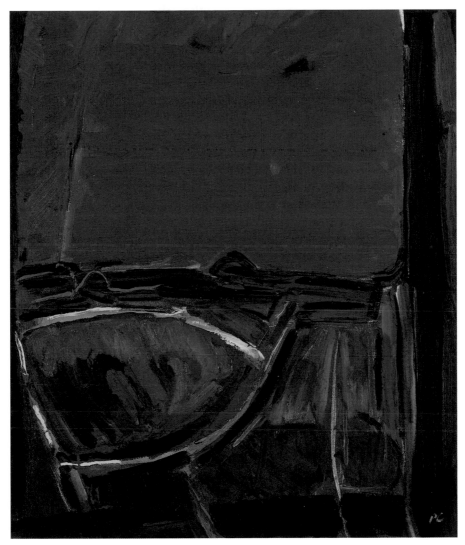

Peter Coker RA
Towards the Pont Neuf from the
Hotel Châtelet
Oil
101 × 85 cm

Gallery VI

Education has been central to the Academy's activities right from the beginning. The RA Schools were founded as an integral part of the Academy in 1768, and are the oldest institution for the training of fine artists in Britain (and among the oldest in the world).

So Fred Cuming's concern about the diminishing number of students and young artists included in the exhibition is understandable. 'I don't know whether it's because they can't afford the send-in fee,' he says, 'or because they believe they don't stand a chance. But to encourage them we thought we'd reserve a gallery for them, and this is it. We invited students from the four main London colleges to send in work for consideration.'

Cuming and Brendan Neiland, Keeper (and therefore principal) of the Schools, who hung the selected paintings, prints and sculptures, know that the choice of works and, indeed, the notion of reserving such a large space for such a purpose is intensely controversial. No doubt art schools other than the chosen four (the Slade, the Royal College, Goldsmith's and the Academy Schools) will resent their exclusion. Also, Neiland invited four students who'd already graduated to submit.

Controversial or not, the result, in general, pleases him. 'What this room demonstrates, I think, is that painting isn't dead by any means. Nor is figuration. And subject matter is still important. I'm glad we've got this room because it tells everybody that young art is very important to us at the Academy. And we may well be looking at some future Academicians among the artists here.'

One of them might be Christian Ward, one of the most successful of recent graduates, whose phantasmagorical landscapes cheerfully risk accusations of kitsch. Ian Monroe, whose highly personal depictions of banks of television sets and other electrical equipment, might be another, though the fact that he's already represented in the Saatchi Collection isn't necessarily a recommendation in some quarters.

Inevitably, the gallery is dominated by Lykke Tavell's sculpture *EN*, three huge steel hoops suspended from almost invisible wires, and partly threaded with blue wool. For boldness, though, Günther Herbst's *Self-drive* runs it a close second. It's a large expanse of canvas inscribed with assertive, cheekily casual stenographic brush marks.

Whatever your view of the quality (and promise) of what's on show here, there's no doubt about the variety of media employed. Apart from paintings and sculptures, there are also photographs and prints. One of the latter is Richard Galloway's strong woodcut *Hackney Siege*. It looks as though he personally observed the dramatic, extended events from his own bedroom window.

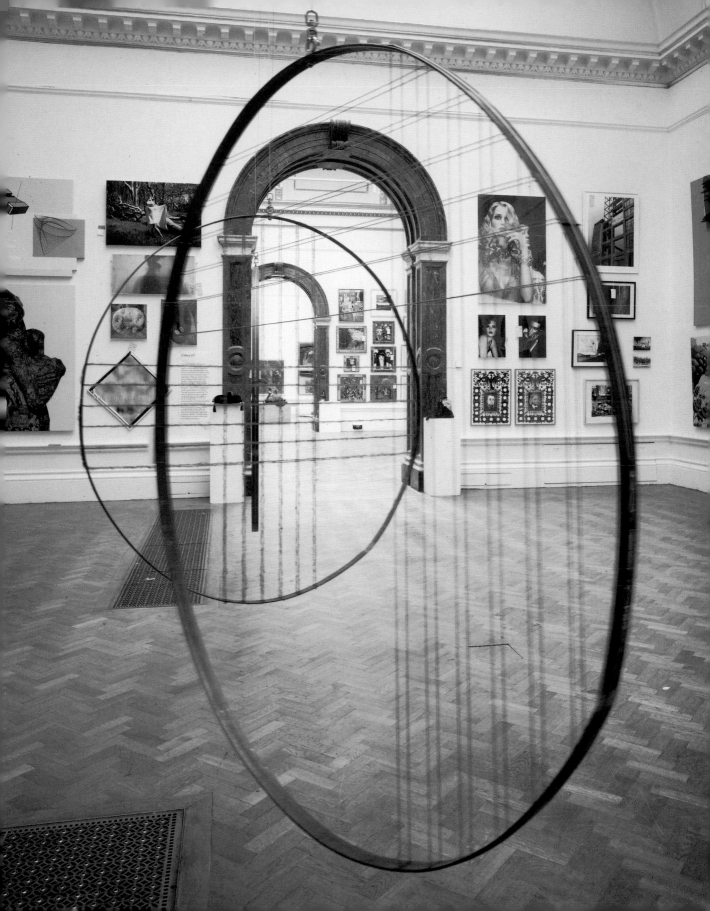

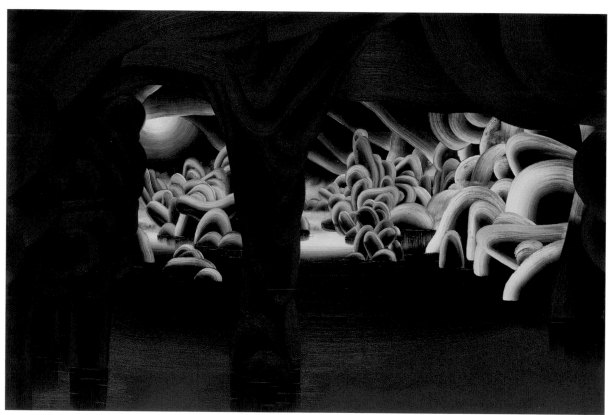

Christian Ward
Red Flood
Oil
136 × 202 cm

Gavin Nolan
If Man Is Five
Oil
217 × 254 cm

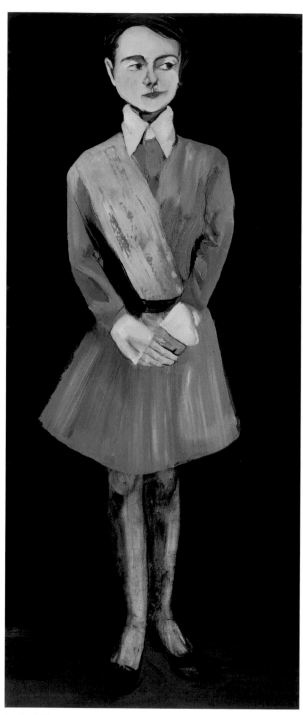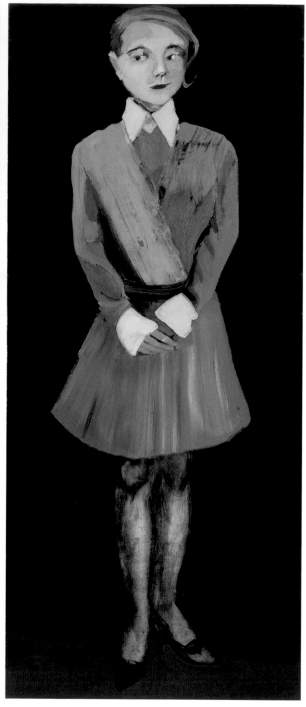

Michael Ajerman
Two Women in Grey
Oil
165 × 140 cm

William Daniels
The Abbey in the Oak Wood
Oil
19 × 54 cm

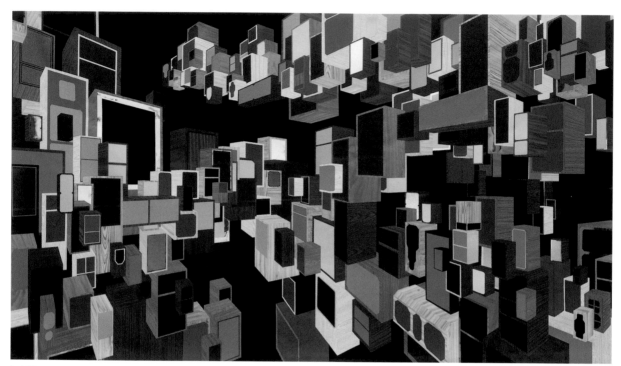

Ian Monroe
Cumulus
Mixed media
185 × 307 cm

Juan Carlos Bolivar
Pinocchio
Acrylic
191 × 168 cm

Michael Stubbs
Gleamer
Mixed media
198 × 198 cm

Günther Herbst
Self-drive
Acrylic
190 × 238 cm

Gallery VII

Mick Moon and John Hoyland hung this gallery of what are not entirely happily known as 'send-ins': in other words, works by non-Members. Some of the names of those who successfully submitted pieces for consideration by the Selection Committee (which also comprises the hangers) are very distinguished, though, and they include Richard Smith and Roy Oxlade.

Not that names affect the selectors' judgement. As though to emphasise that he's not at all influenced by reputation, Mick Moon singles out Gary McDonald for special praise. Still a student at the RA Schools, McDonald's showing two still-lifes whose colours and handling are gentle, understated and in part the result of intention informed by chance. Moon also points to Philippa Stjernward's emblematic painting that, involving the use of wax, looks a bit like a tablet discovered by an archaeologist, incised with some indecipherable script. Moon likes Tricia Gillman's and Daniel Pulman's compositions, too. 'So much in this gallery is about mark-making, and most of the works here are satisfyingly on the edge between abstraction and figuration,' Moon says.

Noel Forster's optically challenging composition of overlapping geometric systems is entirely abstract, however, although Patrick Brandon's *Interior with Canyon – Dusk* quickly becomes legible, as does Roy Oxlade's graffiti-like *Pink Scissors*. Michael Horovitz's *Postcard from Ireland* is a riot, a rollicking salmon-fishing scene, dialect expletives, excited dog, pint of Guinness and all.

More abstract than figurative, John Potter's *The Ballad of the Moon* has affinities with nature nevertheless. The moon itself and the unusual technique, in which areas of flat, covering paint isolate the image, are reminiscent of Max Ernst, though Potter's methods – they include manipulated coloured photocopies – are entirely his own.

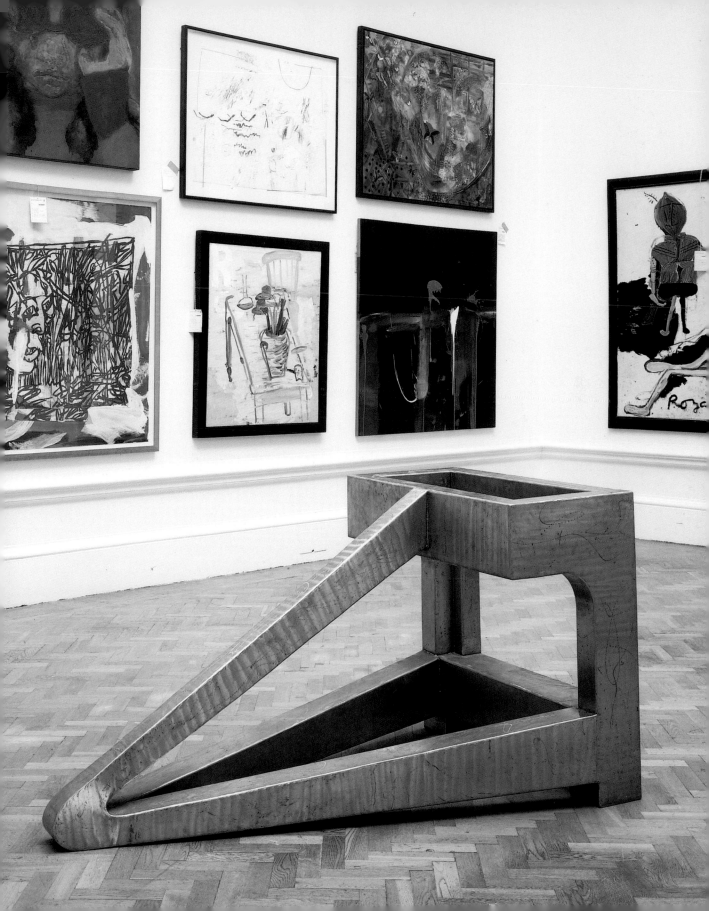

Roy Oxlade
Pink Scissors
Oil
122 × 101 cm

Gary McDonald
Flora
Oil
61 × 75 cm

Angela Braven
Escape
Acrylic
123 × 152 cm

Mary Malenoir
Anubis on Her Pockets and Poison on Her Lips IV
Mixed media
95 × 121 cm

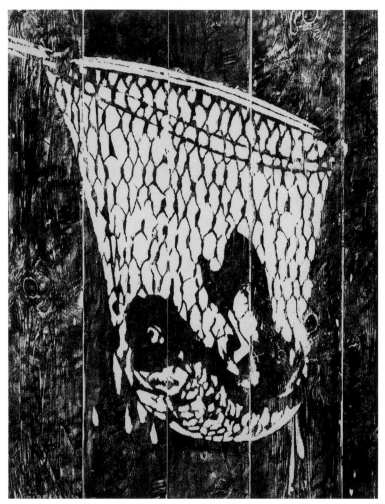

Richard Wincer
The Net
Woodcut
85 × 62 cm

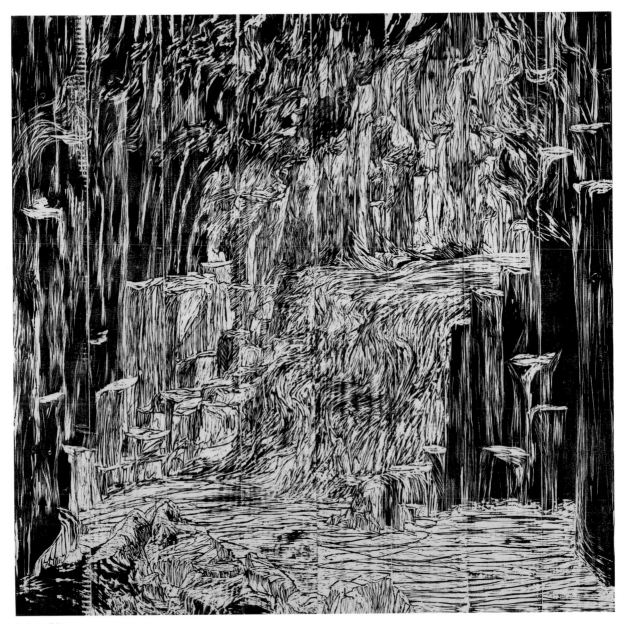

Orit Hofshi
Pilasters
Woodcut
175 × 175 cm

Michael Horovitz
A Postcard from Ireland
Mixed media
203 × 124 cm

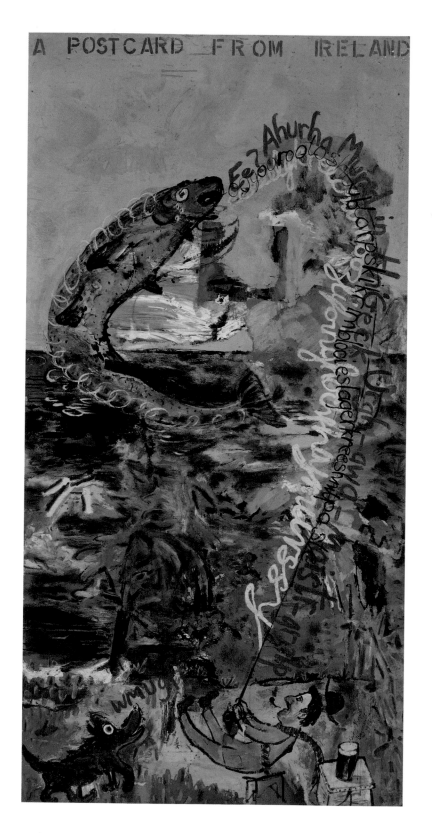

David Hegarty
Self-portrait
Oil
61 × 76 cm

Sheila Girling
Mirror Image
Acrylic
169 × 140 cm

Patrick Brandon
Interior with Canyon – Dusk
Mixed media
88 × 69 cm

Noel Forster
Untitled 03 2003
Oil
183 × 152 cm

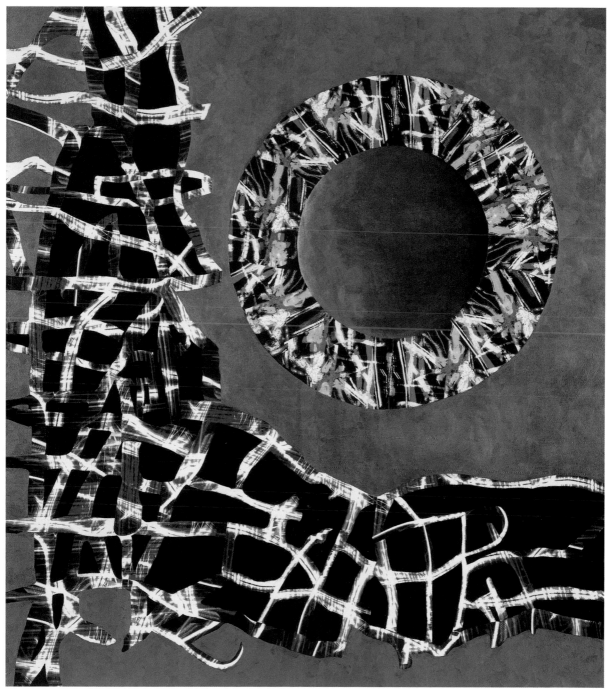

John Potter
The Ballad of the Moon
Mixed media
173 × 153 cm

Gallery VIII

Anthony Whishaw, who hung this gallery of submitted work, says that his aim was to include as many pieces in as many visual languages as possible without making it seem overcrowded. Describing some of the pictorial themes as 'subplots', Whishaw refers to 'sympathetic groups in terms of texture, colour, and subject'. One of them consists of small prints relating to the landscape and gardens, another is a collection of dogs. There's 'an art-history ghetto, in which the pictures freely quote from masterpieces of the past, and a wall of deceptively straightforward abstracts that includes Michele Rio's *Digital Name* and Gerald Keon's *Beach Fragments*.'

Conceding that a gallery like this is difficult to hang, because 'the submitted work gets better and better year by year while the space regrettably remains the same', Whishaw nevertheless adds that he enjoys 'fitting it all together, even though it does take two weeks out of your life'.

Whishaw, who spent days mostly sitting, gazing at his installation and making minor alterations here and there, says he wanted 'changes of pace without staccato interruptions. I began with the Basil Beattie, on the end wall, because it can be seen from one end to the other of this linked suite of galleries, and progressed from there, making sure I kept all the brightly coloured things away from it.' Whishaw has put all the small works at eye level; works that don't require that kind of intimacy can be seen to good advantage higher up.

Fred Cuming describes this gallery as 'a masterpiece of hanging. There are more than 100 works here, but it looks as though there's all the space in the world. Taken together, it's a beautiful abstract in its own right. Rather like one of Tony Whishaw's paintings, in fact.'

Among those hundred works are Basia Lautman's drypoint *Running Away*, in which some strangely humanised, whimsical animals reminiscent of Saul Steinberg are doing just that, and large, deceptively casual (and humorous) pictures by Rose Wylie and Georgia Hayes.

Like Alfred Hitchcock in his films, some of the hangers like to put one of their own works in the rooms they hang. So where's the Whishaw? They're all elsewhere, in Galleries III and IV.

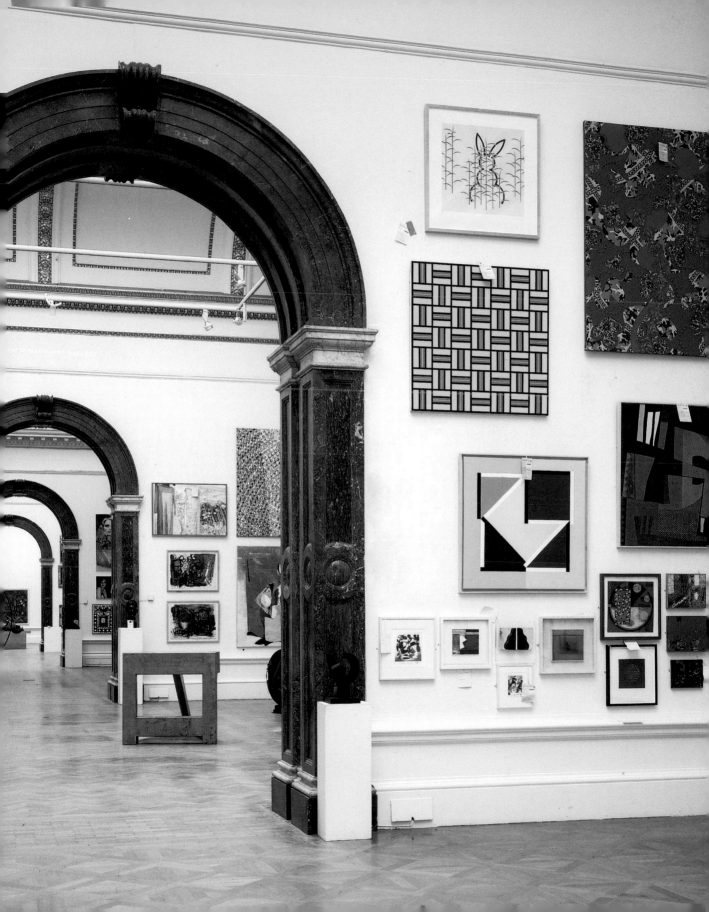

Michele Rio
Digital Name
Mixed media
141 × 90 cm

Basil Beattie
Round and Round We Go
Mixed media
228 × 274 cm

Basia Lautman
Running Away
Drypoint
41 × 33 cm

Day Bowman
Nazca III
Oil
30 × 24 cm

Gerald Keon
Beach Fragments
Mixed media
75 × 45 cm

Richard Elliott
GSGB16RE
Acrylic
52 × 52 cm

Nick Fox
In the Woods No. 49
Mixed media
76 × 61 cm

Georgia Hayes
Kandahar
Oil
183 × 212 cm

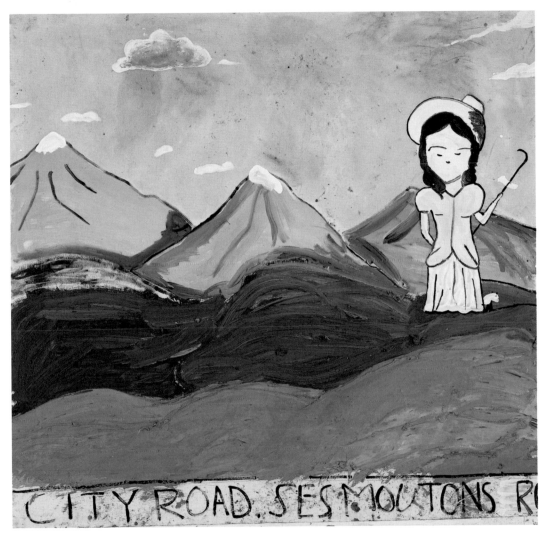

Rose Wylie
City Road
Oil
189 × 194 cm

Noel Myles
Second Film of 'The Three Trees'
Platinum print
61 × 53 cm

Tricia Gillman
Silver Lining
Oil
81 × 92 cm

Gallery IX

If, as Walter Gropius, founder of the Bauhaus, announced in the school's manifesto, 'the ultimate aim of all creative activity is the building!', then the Academy's architect Members are usually given short shrift at the Summer Exhibition. They get just one room in which to show the work of Academicians and non-Members. After all, architects as well as painters and sculptors have been an important part of the institution from the very beginning, and twelve of the eighty Academicians must always be architects. There's always been a place at the Summer Exhibition for the architects, too, though so much always has to be fitted elegantly and informatively into such a little space. What's more, as Edward Cullinan, one of the hangers, says, 'it's not possible to dot architectural exhibits here and there throughout the exhibition as one does with sculpture. They would simply look out of place.'

This year's display is as varied as ever, a rich mixture of everything from prints (Ian Ritchie's calligraphic etching, for example) and design drawings to models, photographs (Frank Gehry's intensely coloured prints of a model for a building in Panama), graphics, computerised images, and sculpture (or in the case of Nicholas Grimshaw's undulating wooden model of the roof of the Southern Cross Station in Melbourne, an elegant object that looks very much like a minimalist sculpture with Op-art intentions).

Several of the drawings don't seem to be connected to architecture in any way, a fact welcomed by Edward Cullinan, who hung the room with Michael Manser and Norman Foster. 'Yes, we've enjoyed the return to drawing enormously. We've got one whole wall of drawings – look for example at the intense pen-and-ink composition by Pete Hull.' It would be strange, then, if Cullinan himself weren't to have some of his own inventive drawings here: *Sketches for a Library at Fitzwilliam College, Cambridge.*

Painting has a place as well, in the form of a large, panoramic, hyper-realist view of Zurich by Ben Johnson. And there's even a highly traditional watercolour of an aristocratic Irish interior by Carey Clarke.

But architecture dominates these images, as it does the whole gallery, optically at least, in the shape of Will Alsop's exercise in city planning, *All that Barnsley Might Dream*, a perspex and Dayglo extravaganza of a model that includes among its many elements some small cuddly toys around the perimeter. It's furnished with headphones, too, so you can hear a commentary about Alsop's intentions.

Edward Cullinan regrets that more architect non-Members don't submit work to the Summer Exhibition. 'Given that there are something like 33,000 professional architects in Britain today, it's a startling fact that the only work submitted to the Summer Exhibition comes from a small number of practices in the metropolitan area. I'd welcome many more things from all over the country.'

He's too diplomatic to say that the architects are given too little space at the Summer Exhibition. But he does express his delight that the Lecture Room is also devoted to architecture this year: to Lord Foster's installation of models of skyscrapers. 'Not to be outdone, we, too, have insisted on four of our own high buildings in this gallery. They pin down the four corners of the room.'

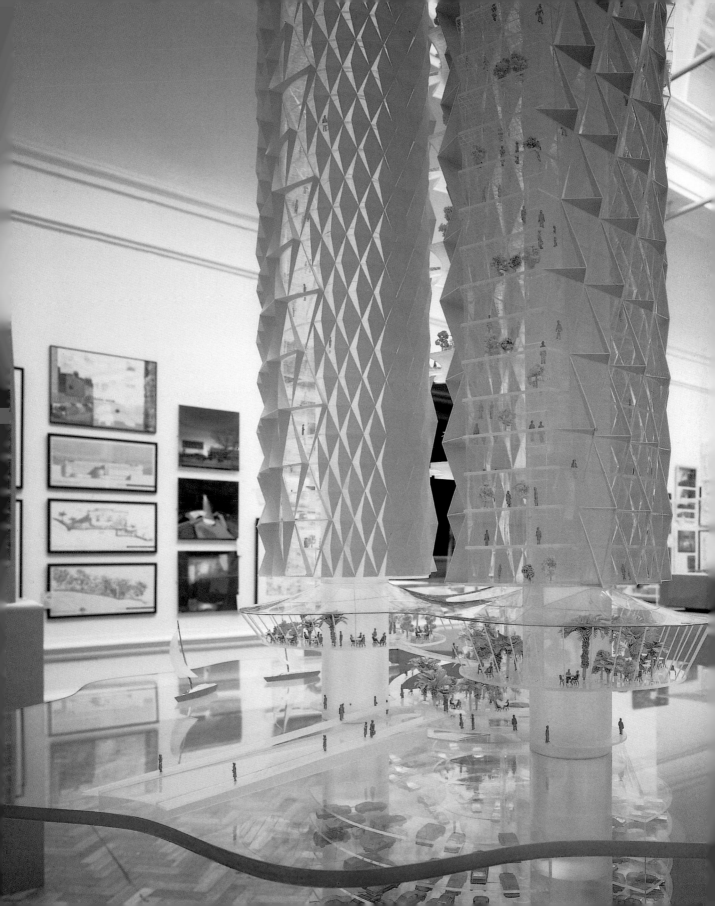

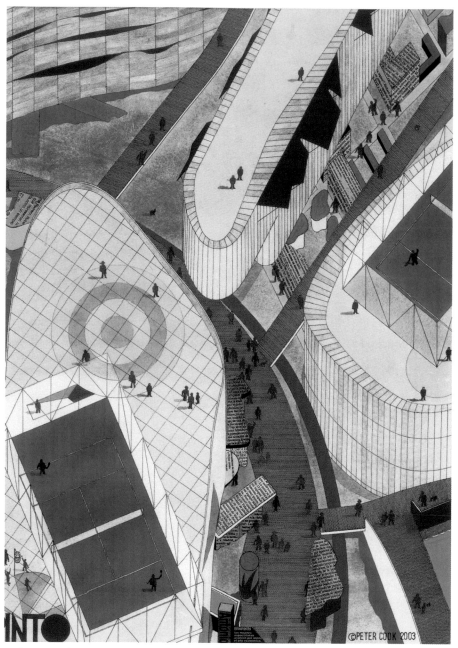

Prof. Peter Cook RA
Pinto (Madrid), Second Corners
Mixed media
69 × 49 cm

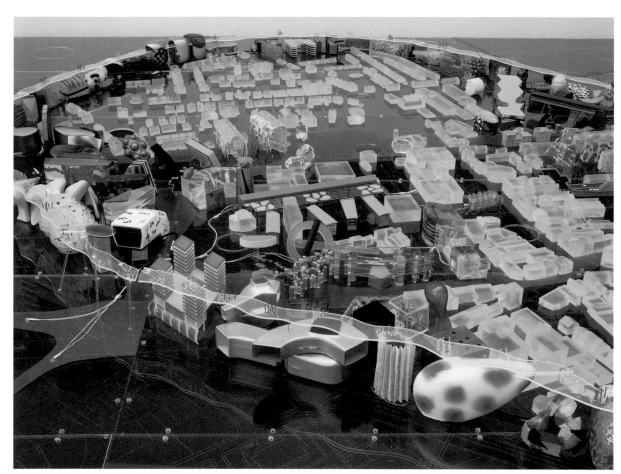

Prof. William Alsop OBE RA
All that Barnsley Might Dream
Model
H 105 cm

Ian Ritchie CBE RA
Whitecity
Etching
15 × 24 cm

Leonard Manasseh OBE RA
Why Not
Mixed media
14 × 20 cm

Sir Richard McCormac CBE RA
*Celebrating 30 Years
of Building* (drawn by
Pete Hull)
Pen and ink
80 × 112 cm

Edward Cullinan CBE RA
*Sketches for a Library at Fitzwilliam
College, Cambridge*
Mixed media
31 × 31 cm

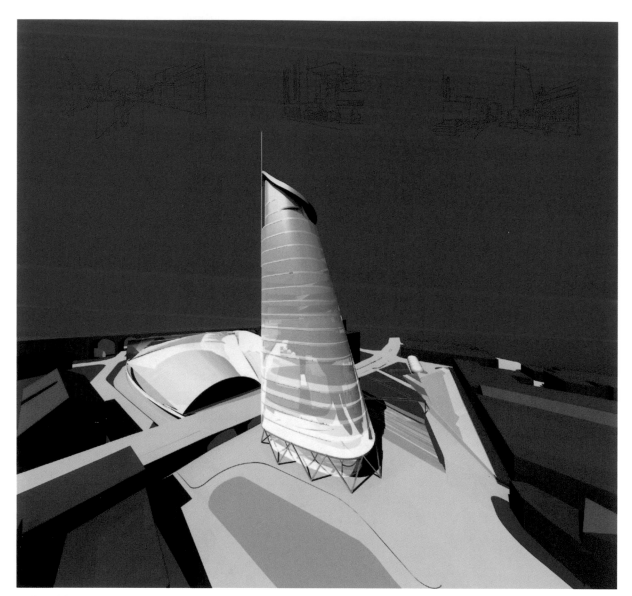

**Paul Koralek CBE RA (Ahrends,
Burton & Koralek Architects)**
Stockport Town Centre
Digital image
55 × 55 cm

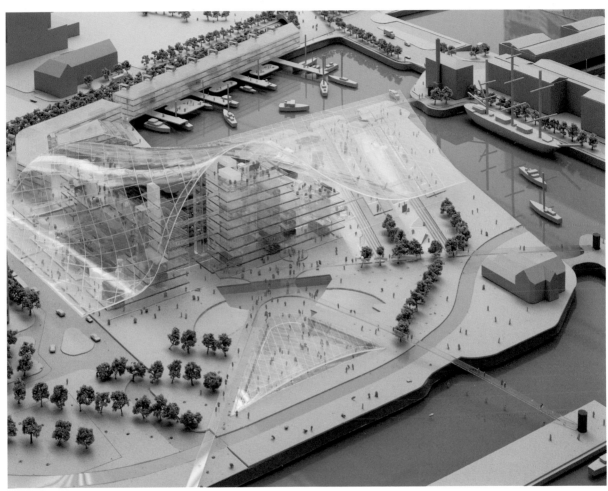

**Lord Rogers of Riverside RA
(Richard Rogers Partnership)**
Fourthgrace, Liverpool
Model
H 40 cm

Eva Jiricna CBE RA (Eva Jiricna Architects)
Hotel Josef, Prague (detail)
Digital image
53 × 73 cm

Sir Nicholas Grimshaw CBE RA
Southern Cross Station, Melbourne
(roof and structure)
Digital image
49 × 112 cm

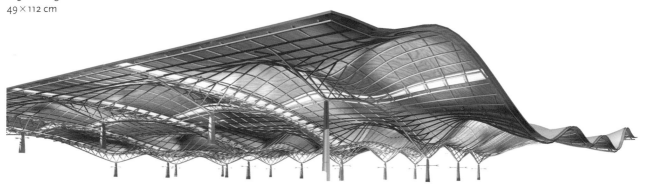

Prof. Trevor Dannatt RA (Dannatt, Johnson Architects)
The Fleming Collection Gallery
Photograph
90 × 60 cm

Frank O. Gehry Hon RA
Puente de Viba, Panama
Photograph
60 × 75 cm

**Lord Foster of Thames Bank
OM RA (Foster and Partners)**
Rebuilding the World Trade Center
Photomontage
59 × 84 cm

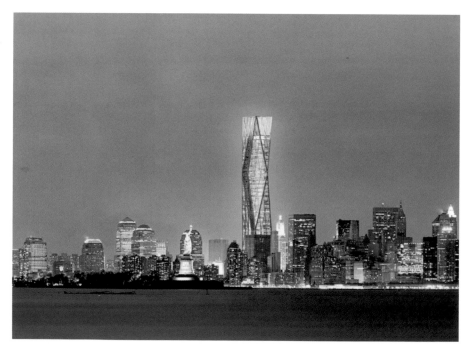

Piers Gough CBE RA
Bankside Studios
Pencil on paper
65 × 90 cm

Michael Manser CBE RA
Photographic Studios, West London
Ink and pantone on trace
36 × 76 cm

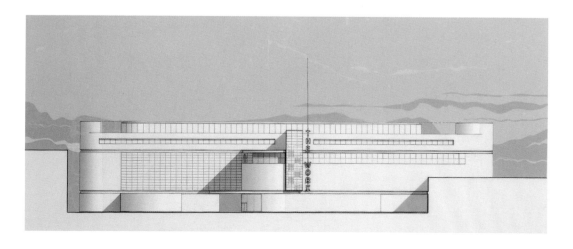

Talking to Lord Foster you might think he believes that high-rise buildings are universally thought to be a bad thing. Asked to say something about the purpose of this dramatic installation, he simply replies 'to celebrate the skyscraper', before adding, after a well-timed pause, 'That'll upset a lot of people.'

Foster is, of course, well-known for his positive views about high-rise and high-density living, and even if you don't share them, you can't fail to be impressed by this breathtaking arrangement of beautifully constructed models of some of the world's most famous skyscrapers. Set above eye level on two massive plinths running the length of the gallery, each representing one of the two hemispheres, the models (about 50 of them in all) are arranged according to their locations: 'East' or 'West'.

In the 'West' we find such historic buildings as the Chrysler Building (by William Van Allen) and Mies van der Rohe's Seagram Building as well as many much more recent projects. A noticeable emphasis on London is evident, including the London Bridge Tower by Renzo Piano and 30 St Mary Axe by Foster and Partners.

The display is an object lesson in how the skyscraper has evolved though time and in how various the treatment of the high-rise concept can be. It's also a declaration of faith at a time when many architects are still reeling from the implications of the destruction of the World Trade Center.

The beautifully made models are impressive in themselves, but the way in which they're displayed here makes them seem more impressive still: as works of art in an installation that will linger in the memory.

'Taller buildings', says Foster, 'can accommodate more people, at greater densities, seeking to create a higher quality of urban life.' The display has a message, then. So it's appropriate that it should be located in the Lecture Room (though lectures haven't been given here for years).

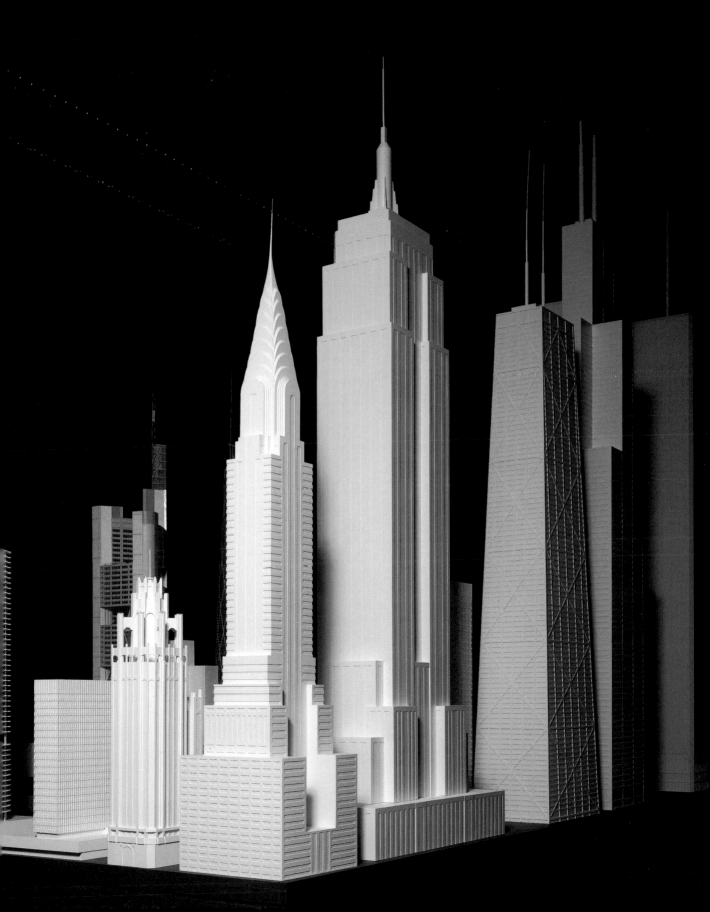

Skidmore, Owings & Merrill
7 South Dearborn, Chicago
Model
H 120 cm

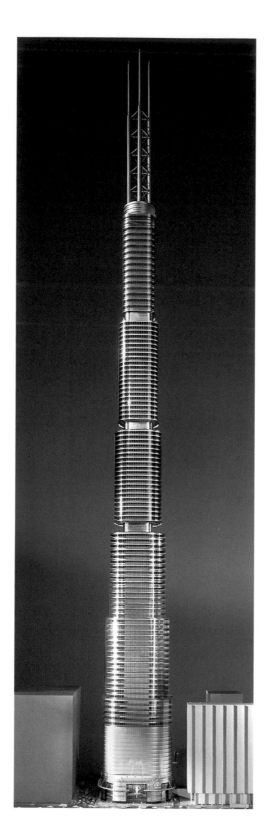

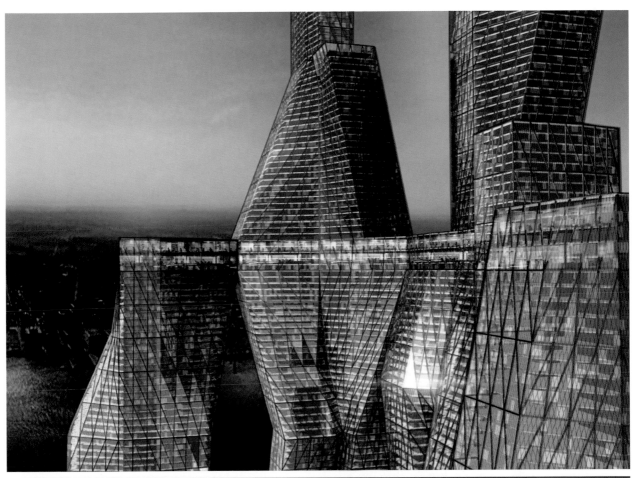

United Architects
World Trade Center, New York 2002
Photomontage

Traditionally, the Summer Exhibition includes special displays of work by Academicians and Honorary Academicians who have died during the previous year. This exhibition therefore pays tribute to Matta (Gallery III) and, here in the Wohl Central Hall, Eduardo Chillida (1924–2002). (Since the renowned sculptor Lynn Chadwick and the distinguished architect Philip Powell died during the hanging of this year's exhibition, their work will be specially featured in twelve months' time.) Chillida's sculpture and prints were selected by Phillip King, President of the Royal Academy and, of course, a fellow sculptor.

Chillida was Spanish, born in San Sebastián in the Basque country, where he spent most of his life. His work is abstract, though this is a description he was never happy with. Much of his sculpture is in iron wrought under intense heat with the skills of a blacksmith (he worked with one for a time). But some of Chillida's sculptures are in carved stone. They manipulate space, use voids and other empty areas as significant parts of compositions in ways that recall architecture (the alabaster shown here is called *Heterodox Architecture*), so it's not surprising to learn that Chillida studied architecture for a time before deciding, not long after the Second World War, to become first a painter and then a sculptor (he also had another career for a short time: a brilliant professional soccer player, he kept goal for the famous San Sebastián team Real Sociedad).

Each of the sculptures here is in one of two of Chillida's favourite materials, iron or alabaster. One of the iron sculptures, *Peine del Viento XVII*, is related, as its title suggests, to his most famous monument, the *Wind Combs*, a series of sculptures embedded in the rocks on the shoreline at San Sebastián, dramatically breasting the surf, the wind and the rain.

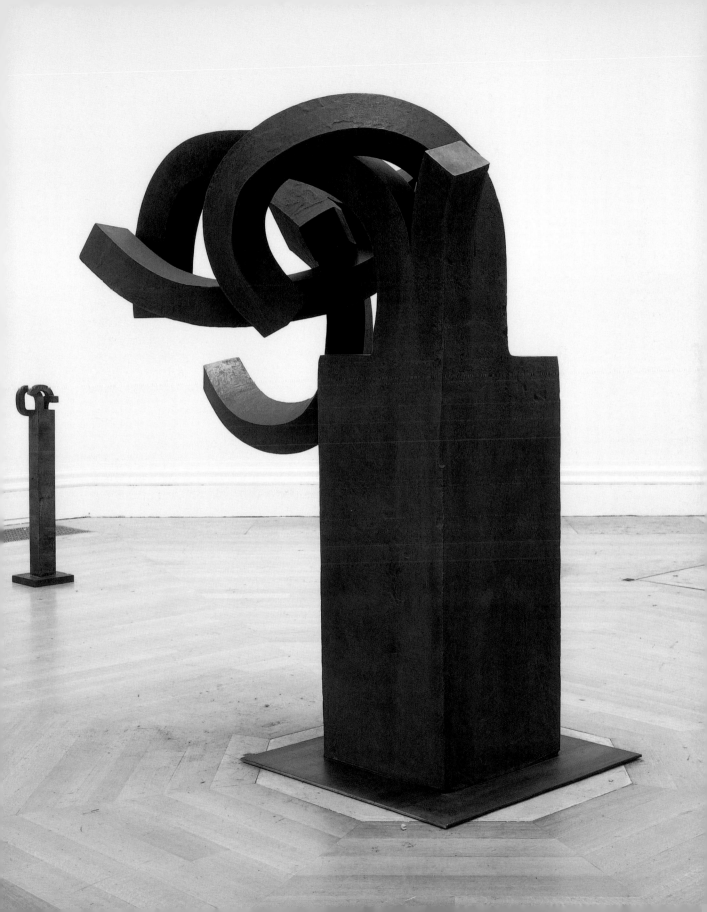

Eduardo Chillida Hon RA
Arquitectura Heterodoxa III
Alabaster
H 54 cm

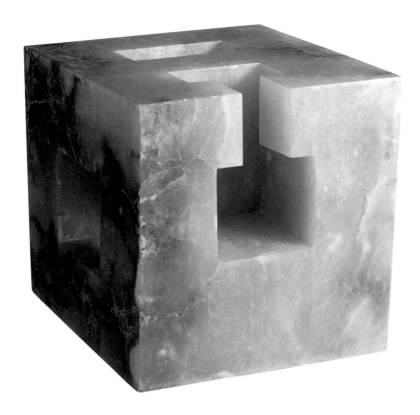

Eduardo Chillida Hon RA
Zubi Arundi
Aquatint
160 × 123 cm

Gallery X

You can see why Fred Cuming describes this gallery as the 'grand finale' of the exhibition. Dedicated to the work of Anthony Green, it's dominated by the enormous – and unforgettable – *Resurrection*, part sculpture, part painting and part installation. Like so much of Green's always unconventional work, it's autobiographical, a synthesis of biographies of various members of the Green family, living and dead, each of whom is at a different stage of a journey to heaven. Involving several generations, *Resurrection*'s pictorial stories are about lust and infidelity, ambition and disappointment, and they're located in claustrophobic, over-decorated interiors and on suburban streets. (Limbo is the waiting room at Gospel Oak railway station, and the Gates of Paradise are the French windows of a flat in an Edwardian mansion block surmounted by a 1,000-watt light bulb.)

Green's mother is shown emerging naked from a clock; his cousin struggles on a carpet in the embrace of a matelot; and the artist and his wife float out through the flap of a tent where they have clearly not been reading the Beatitudes. The entire edifice is dominated by the huge head of Green himself observing several generations' worth of comedy, tragedy and family gossip, as though Gulliver had stuck his head up through the floor of some Lilliputian attic in the middle of a riotous assembly.

There's Casimir Dupont, Green's grandfather (formerly *chef de cuisine* at the Waldorf); there's Dupont's daughter – Green's mother – fleeing from his father at the flat in Lissenden Mansions into the arms of a lobster merchant; there are his uncles and aunts 'dead and neatly packaged in a suitcase, waiting for onward passage to eternity'; and, above all, there's Green himself, enjoying the domestic delights of married life until his guardian angel 'shepherds him onto the balcony for a final swoop down to the railway and the trip to Paradise'.

Resurrection is a complicated piece of carpentry and engineering not unlike a carnival float. Ten feet high, and almost twenty feet long, it took Green three years to make. Though most of its surfaces are painted in an obsessively detailed style, it's also fully furnished with such real memorabilia as a ticking clock, a chandelier that lights up at regular intervals, a leather suitcase packed with dolls of deceased relatives 'made in linen from my mother's trousseau', as well as a carpet strewn with everlasting flowers.

Green created this extraordinary work just before the millennium, and then showed it in various cathedrals around the country. It is the largest and most involved work he has ever created. It is arguably also his masterpiece.

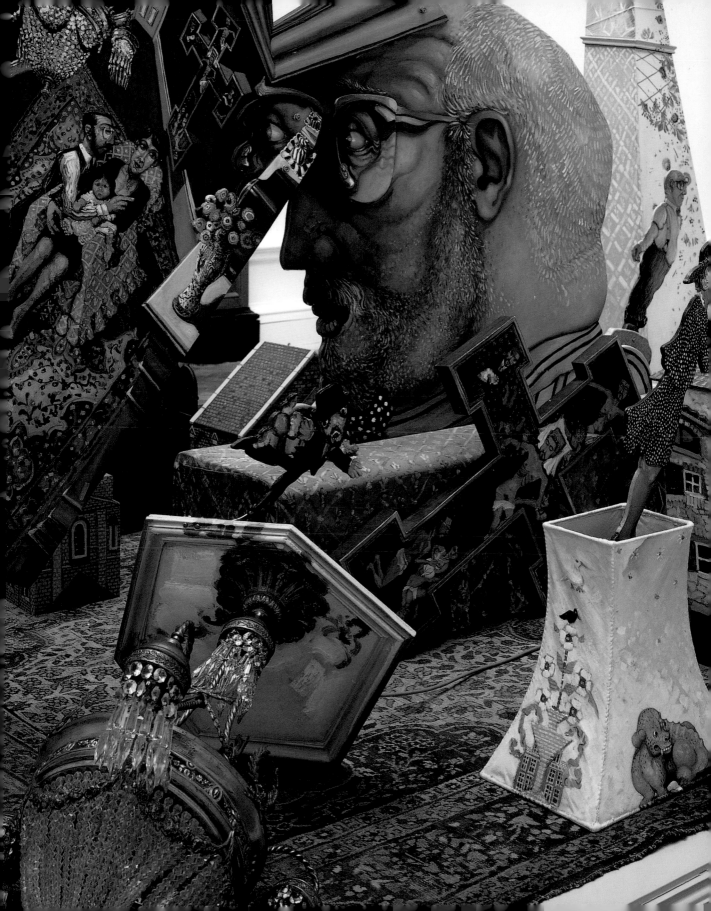

Anthony Green RA
The Tent of Eternal Love
Giclée
76 × 112 cm

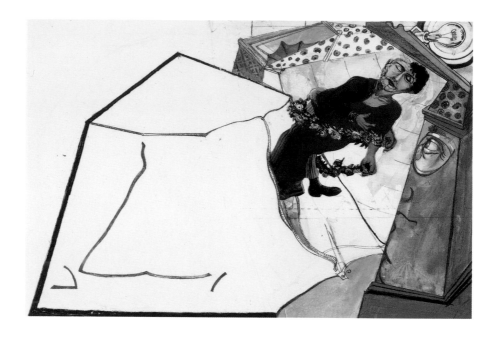

Anthony Green RA
*Resurrection: A Pictorial
Sculpture for the Millennium*
Mixed media
H 305 cm

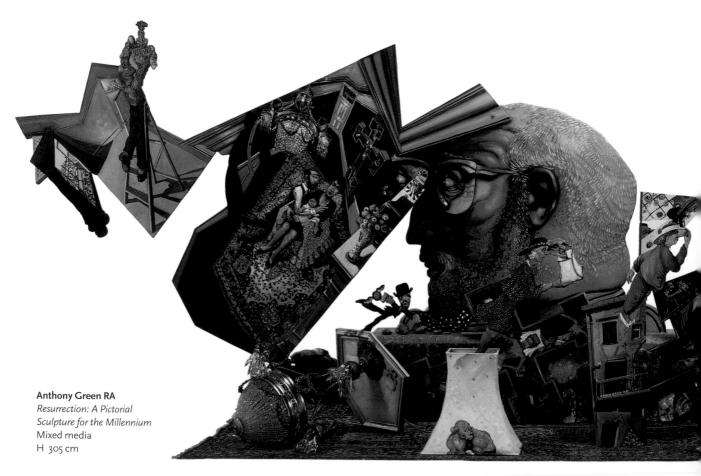

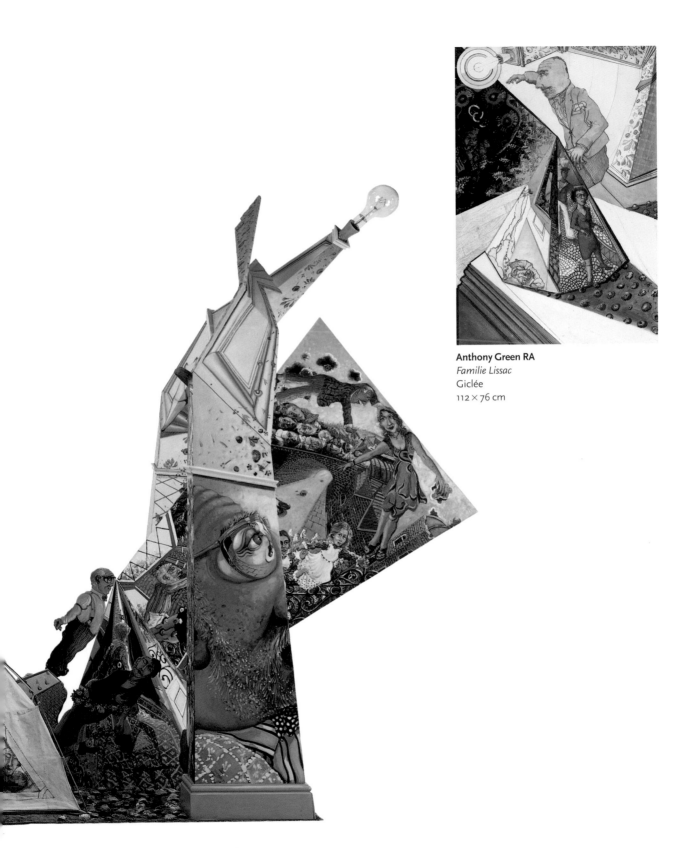

Anthony Green RA
Familie Lissac
Giclée
112 × 76 cm

Index

Royal Academy of Arts in London, 2003

Royal Academy Trust

Registered charity number 1067270

The Royal Academy of Arts, Registered Charity number 212798, is Britain's founding society for promoting the creation and appreciation of the visual arts through exhibitions, education and debate. Independently led by eminent artists and architects, the Royal Academy receives no annual funding via the government, and is entirely reliant on self-generated income and charitable support.

You and/or your company can support the Royal Academy of Arts in a number of different ways:

- £46 million has been raised for capital projects, including the Jill and Arthur M Sackler Wing, the restoration of the Main Galleries and the redesign of the courtyard.
- Future projects include the restoration of the Fine Rooms, and the provision of better facilities for the display and enjoyment of the Academy's own Collections of important works of art and documents charting the history of British art.
- Donations from individuals, trusts, companies and foundations also help support the Academy's internationally renowned exhibition programme, the conservation of the Collections and educational projects for schools, families and people with special needs; as well as providing scholarships and bursaries for postgraduate art students in the RA Schools.
- Companies invest in the Royal Academy through arts sponsorship, corporate membership and corporate entertaining, with specific opportunities that relate to your budgets and marketing/entertaining objectives.
- A legacy is perhaps the most personal way to make a lasting contribution, through the Trust endowment fund, ensuring that the enjoyment you have derived is guaranteed for future generations.

To find out ways in which individuals, trusts and foundations can support this work (or a specific aspect), please contact Vanessa Bowcock on 020 7300 5698 to discuss your personal interests and wishes.

To explore ways in which companies can become involved in the work of the Academy to mutual benefit, please telephone Jane Richards on 020 7300 5705.

To discuss leaving a legacy to the Royal Academy of Arts, please telephone Sally Jones on 020 7300 5677.

Membership of the Friends

Registered charity number 272926

The Friends of the Royal Academy was founded in 1977 to support and promote the work of the Royal Academy. It is now one of the largest such organisations in the world, with around 87,000 members

As a Friend you enjoy free entry to every RA exhibition and much more...

- Visit exhibitions as often as you like, bypassing ticket queues
- Bring an adult guest and four children, all free
- See exhibitions first at previews
- Keep up to date through RA Magazine
- Have access to the Friends Rooms

Why not join today

- Onsite at the Friends desk in the Front Hall
- Online on www.royalacademy.org.uk
- Ring 020 7300 5664 any day of the week

Support the foremost UK organisation for promoting the visual arts and architecture – which receives no regular government funding. Please also ask about Gift Aid.

Summer Exhibition Organisers
Lucy Anderson
Edith Devaney
Harriet Sawbridge

Royal Academy Publications
David Breuer
Harry Burden
Carola Krueger
Fiona McHardy
Peter Sawbridge
Nick Tite

Book design: 01.02
Photography: FXP and John Riddy
Colour reproduction: DawkinsColour
Printed in Italy

British Library Cataloguing-in-
publication Data
A catalogue record for this book is
available in the British Library

ISBN 1-903973-17-1

Illustrations
Page 2: Barbara Rae RA, *Western Boundary* (detail)
Page 4: Georg Baselitz Hon RA, *Juri* (detail)
Page 6: Sandra Blow RA, *Over the Traces* (detail)
Page 8: Eduardo Chillida Hon RA, *Felt* (detail)
Page 11: Gallery I, showing Nicola Hicks, *Limbic Champion*, and Mimmo Paladino Hon RA, *Cavallo*
Page 23: Gallery II, showing Lynn Chadwick RA, *Trigon*, 1961, and Bill Woodrow RA, *Out of Africa*
Page 37: Mick Moon RA, *Last Drop* (detail)
Page 61: The Small Weston Room
Page 75: Gallery III, showing Geoffrey Clarke RA, *Sculptor and Aesthetic Detector*
Page 99: Prof. John Hoyland RA, *Master Weaver 2.11.02* (detail)
Page 107: Fred Cuming RA, *Ferry to Polrwen* (detail)
Page 129: Gallery VI, showing Lykke Tavell, *En*
Page 139: Gallery VII, showing Paul Neagu, *Stainless Hyphen*
Page 153: Gallery VIII
Page 165: Gallery IX, showing Sir Michael Hopkins CBE RA, *Offshore Residencies, Dubai*
Page 177: The Lecture Room, showing Norman Foster's 'Sky High' display
Page 181: The Wohl Central Hall, showing Eduardo Chillida Hon RA, *Piena del Viento XVII*
Page 185: Anthony Green RA, *Resurrection: A Pictorial Sculpture for the Millennium* (detail)

Photographic Acknowledgements
Page 8: Photograph © Alan Wylie.
Pages 11, 16: The artist. Courtesy of
Waddington Galleries Ltd.
Page 13: © ARS, NY and DACS,
London 2003. Page 15: Courtesy
of Waddington Galleries Ltd.
Page 21: Courtesy Jay Jopling
(London). Photography: Stephen
White. Page 33: The artist.
Courtesy of Pace Wildenstein
and Waddington Galleries Ltd.
Page 58: © Colin Self 2003.
All Rights Reserved, DACS.
Page 76: Photograph © Moreno
Maggi. Page 78: © Peter Blake 2003.
All Rights Reserved, DACS. Courtesy
of Waddington Galleries Ltd.
Page 90: The artist. Page 105:
Photograph by John Riddy.